OIL PAINTING
SECRETS FROM
A MASTER

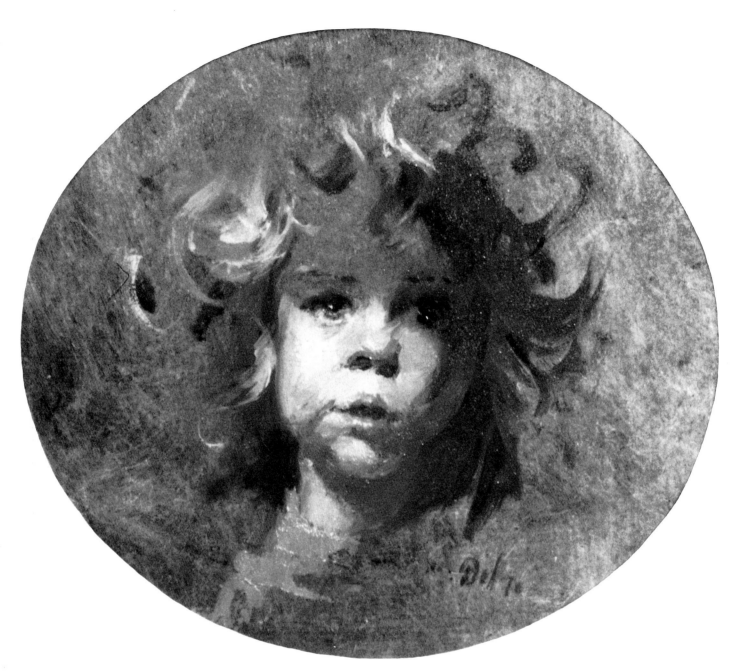

MELISSA *oil, 10" × 12" (25.4 × 30.5cm). Collection of Melissa A. Leffel.*

OIL PAINTING SECRETS FROM A MASTER

BY LINDA CATEURA

WATSON-GUPTILL PUBLICATIONS/NEW YORK

Published in 1995 in the United States by Watson-Guptill Publications,
Nielsen Business Media, a division of The Nielsen Company
770 Broadway, New York, NY 10003
www.watsonguptill.com

Library of Congress Cataloging-in-Publication Data
Cateura, Linda.
 Oil painting secrets from a master—Pb. ed.
 p. cm.
Includes index.
1. Painting—Technique.　　I. Title.
NC1500.C38　1995　751.45　84-11997

 ISBN-13: 978-0-8230-3279-2
 ISBN 0-8230-3279-5

Distributed in the United Kingdom by Phaidon Press Ltd.,
Littlegate House, St. Ebbe's St., Oxford

Manufactured in Malaysia

9 10 11 12 13 / 11 10 09 08

*To Henry, who provided me with
the time to write this book.*

Acknowledgment

I wish to express my
appreciation to the Art Students
League of New York, in whose
studios these notes were taken.

CONTENTS

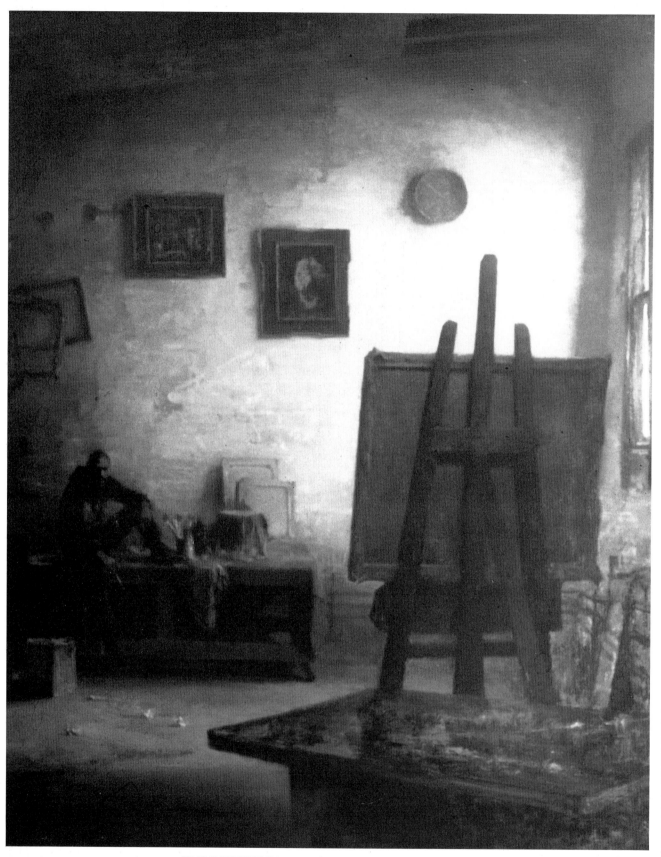

ED HAMILTON'S STUDIO *oil, 50" × 40" (127 × 101.6cm).*

LEFFEL, THE TEACHER

There are many art teachers, but few that can teach art well. As an art student I've had several teachers, but only one who could communicate his visual knowledge and expertise verbally. It's as if in crossing the bridge from the visual to the verbal, many art teachers leave their verbal equipment on the visual shore.

David A. Leffel is the exceptional artist who is both a good painter and a good teacher. His classroom-studio at the Art Students League in New York City, where he has taught for the past 13 years, is a mecca for art students from all over the world. Like the Pied Piper, he is followed around the classroom by his students who crane their necks to see and listen whenever he stops to critique a canvas. He is so popular that his crowded classroom and demonstrations have sometimes been closed off.

Leffel is a highly esteemed teacher because he communicates clearly. He has the extraordinary ability to teach students an artist's thoughts and techniques. This book, based on notes I took in his classes, will attest to that. His phrasing is crystal clear. If known words do not express his thoughts, he'll make some up that do, and they too, oddly enough, will be crystal clear.

Leffel has devoted two lifetimes to his work—one to the study and practice of painting, and the other to communicating to students his acquired knowledge and expertise. He shares with his students a continual search for artistic development and this quality characterizes his teaching. What he says is more likely to be, "Let's consider how the light is falling here," than the more didactic, "This is how the light falls." The student senses that he is not just imparting shibboleths handed down from one teacher to another, but personally thought-out approaches, deeply considered solutions, that this painter-teacher has himself developed in the creation of his art.

Perhaps the quality that has contributed most to his reputation is his generous teaching. From a supply of superhuman abundance and patience, he holds nothing back. All of his techniques, solutions, and know-how, are available to his students; let them but ask. He has said that there is no question he won't answer.

Leffel's teaching has contributed a body of knowledge that has proved and will continue to prove an invaluable resource to artists, students, and art lovers everywhere. In an effort to preserve this contribution, these notes are presented with loving care.

LINDA CATEURA

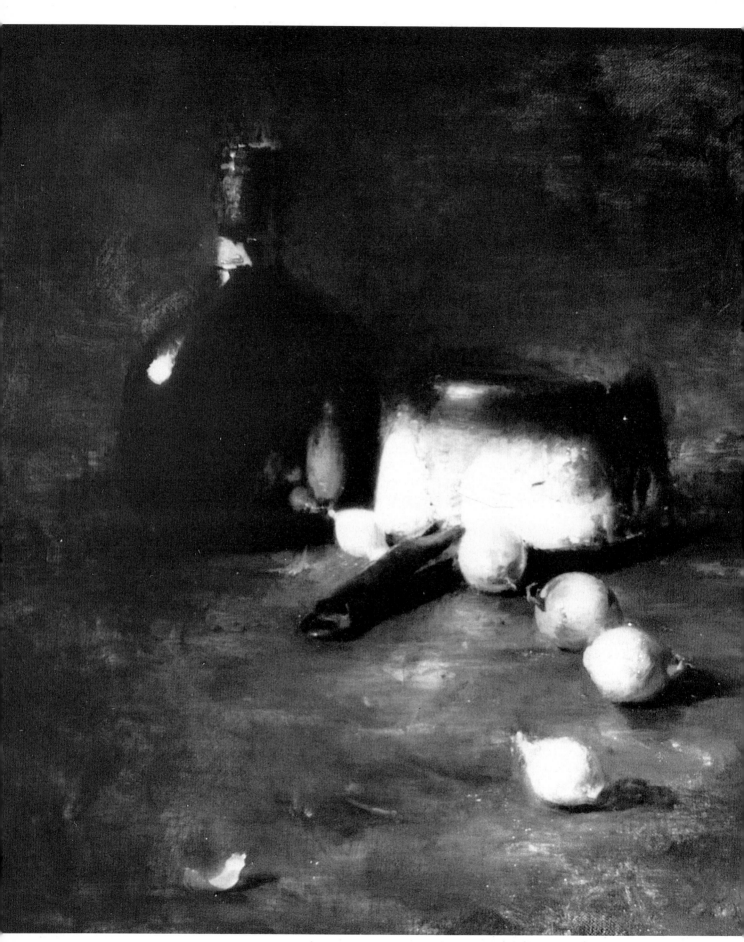

MAROGER PAN AND BOTTLE *oil, 21" × 18" (53.3 × 45.7cm). Collection of the Artist.*

LEFFEL, THE ARTIST

To meet David Leffel, as I did, after you have seen his paintings can be a jolt. His pictures seem at first elegant and austere—yet one of David's most striking personal characteristics is his down-to-earth accessibility. He loves a good story, tells wonderful jokes, and is essentially a warm, vital person. The seeming disparity between David and his paintings though, is an illusion. His paintings are beautiful but they are also warm and accessible.

I remember going over to David's studio for the first time. The room was so dimly lit that its contents, including my host, were barely distinguishable. As my eyes adjusted, however, I saw frames, easels, still life props, and paintings all scattered about the studio. In the center of it all, almost directly under the skylight, was a rickety old table with some onions and an old pot lying on it. There was a painting next to the table and when I looked at it, I got a shock! Instead of depicting the random collection of objects I saw, the painting forced them into roles in a compelling drama of light. The onions were emerging from a dark shadow, getting lighter and lighter, in a sense leading the light to the focal point— the battered pot. With rich impasto and broken color the pot stood out majestically against the dark background, dented and rusted, almost a heroic survivor. The painting had altered nothing in the setup. In fact, it looked more real. But in some way, Leffel had transformed the temporary into something eternal.

All of Leffel's paintings have that quality. Whatever their subject, he has been able to find something in it to lift the picture out of the literal into the realm of the poetic. Each painting is about something other than appearances. While a self-portrait, for instance, might be amazingly true to the way David looks, it may also evoke a deeper response. I am thinking of one that shows David peering intently out of a shadowy darkness, his face only partially lit, suggesting an inward search. The shadowy lighting describes the internal quest. The dimness and intensity of his gaze suggest the difficulty of such a search.

That kind of functional use of light is one of the most distinctive qualities of a Leffel painting. The light leads the viewer through the painting toward the central image. When it reaches this focal point, the light is usually at its most intense and so the eye comes to rest there naturally. Light, in David's hands, becomes the tool by which he directs the eye to the significant. This concept of being led through the painting by the light is a device Rembrandt consistently employed. Rembrandt is an obvious example of a great artist whose paintings always used the light to help tell the story. In the painting of the blinding of Samson, for instance, the spears and the soldiers and the light are all flying toward Samson's eyes with a dizzying violence. The light there doesn't just illuminate the scene—it is an active participant in the drama. Leffel makes no secret of his admiration for Rembrandt, and in many ways can be seen as an heir to that great master.

A realistic painting that combines insightful accuracy with beauty fulfills one of our deepest hopes—that we live in a harmonious world. Leffel's paintings consistently make that statement, for he is a supreme artist.

GREGG KREUTZ
New York-based artist, 1984

11

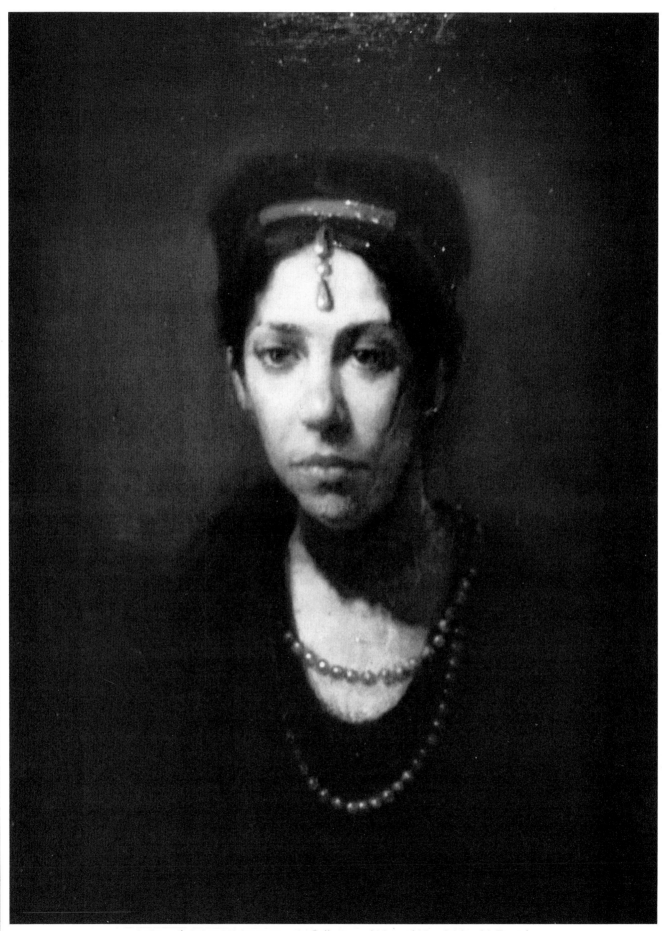

SARA *oil, 24" × 20" (61 × 51 cm). Collection of Mr. and Mrs. Walter McDaniel.*

MY GOALS AS A TEACHER

Since most of you that will read this book will come from outside my classroom, I would like to devote this foreword to acquainting you with my goals as a teacher.

In the classroom, as I walk among my students and easels, I do two things. First, I explain what is technically wrong with the students' paintings: why they don't work or look the way the students would like them to look. Then I follow this up with suggestions for changes that will pull the paintings together. Underlying everything I say is the principle that learning to paint means dealing with problems, not overcoming them.

Secondly, and most important, I point out the reason their paintings aren't working. Poor painting stems from a certain human propensity to let the mind color reality; our assumptions, prejudices, and the habitual patterns of our thinking, all influence what and how we see.

Learning to paint then, is learning *how to see*, to retrain your eye to see not just details, but what is significant enough to paint. This is the crux of learning to paint. On the technical level, learning to paint is relatively easy. Look back at the many, many competent painters there have been since, let us say, the sixteenth century. To repeat, the essential difficulty is learning how to see, *see* as in understand, and to see what is significant. An art-

ist sees what is significant, a painter sees only what to paint.

We go through life visually. We make it through doorways, up and down stairs; we recognize our family and friends and the various substances and textures that surround us, *and all the time we are accepting certain optical illusions as being real*. In everyday life, these illusions don't matter. Yet when we give substance to them on our canvases they don't look "right" or real! Since reality is always "right," if our painting doesn't conform to it, then we did not see correctly and therefore, didn't translate properly. You can't paint what you can't see! Consequently, a large part of learning involves understanding our attitudes and assumptions. Dealing with technical problems as they arise is a much simpler matter.

I have been teaching people to paint for over a decade. In any one class, there are people of all ages, of different backgrounds, but all with what seems to be one common goal: they would like to learn how to paint. But their *motives* for learning are numerous. Some people want to learn because they want to be an "artist" or even a "great artist"; some for fame and fortune; others for relaxation and fun; some to take up the threads of youth when painting was put aside to make a living. Few people want to learn *just to learn* and this is an important distinction. Your motives will de-

termine the quality of your ambition and how much or how little you will learn.

You must ask yourself: "Can I learn unless I'm willing to let go of misconceptions and goals that hinder progress and leave the past and its dried palette behind?"

Learning means leaving security and taking risks. *Talent is actually the ability to take risks*, to attempt different solutions, various ways to begin, imaginative brushstrokes, new colors. If you are reading this book "just to learn" and you're willing to take risks and to try anything or give up anything to learn, you will learn. You will also change because painting requires expanded perception and sensitivity.

The technique of painting is embodied in very few easily understood precepts. Learning to paint is not difficult. You only need common sense. I believe that anyone reading this book who is endowed with visual proclivities, can learn to paint as well as anyone, including the so-called "greats!"

This book includes practical solutions to problems every painter encounters each time he approaches a canvas. Read them for understanding, which is alive and creative; not for acquiring information, which is static. Read with passionate interest; read *behind* the words, and if you do, you will understand the joy of painting and the joy of discovery.

DAVID A. LEFFEL

PART ONE
ARTISTIC THINKING

THE FRAME SHOP
oil, 25" × 30" (63.5 × 76.2cm).
Private Collection.

ON SEEING

What is painting? Painting is visual. If you cannot see, you cannot understand what painting involves, which is seeing in a totally different way from the seeing that takes place in everyday life. You must hear what the teacher expresses verbally and then see with your *own* eyes the translation in reality. Obviously, you can't see it with the teacher's eyes. You can't learn about painting through someone else's experiences, only through your own.

What is painting about? It's understanding what comprises a visual reality and then translating that reality to a canvas through painting techniques. Rubens, for example, had the ability to see objects of nature with a painter's eye, that is, he could immediately see the predominant feature that defines and distinguishes every object and bring this visual reality to his paintings. You can learn how to do this by studying and examining his paintings.

When I use the term "seeing," I don't mean merely using your eyes. When you see with your eyes only, you see a limited reality. Like the blind man in his ef-

fort to see, you touch only one part of reality at a time because when you focus on one thing, you automatically block out everything else. This kind of seeing is called "selective focus." You can choose to see either the dirt on the windshield or fifty yards down the road. But you can't see both simultaneously. The information is all there; what you see depends on how you shift your focus. It's the same in painting; you must keep the right things in focus, you must *see* what you're painting.

That's why if you just copy the model, bit by bit as you look, it will look wrong on canvas. Just matching your canvas to the model doesn't involve real seeing because it doesn't involve *understanding*. You must learn to look beyond the model to understand—and convey—the illusion of a three-dimensional reality onto a two-dimensional canvas.

Thus the intelligent artist who sees selectively and with understanding, sees the canvas as the reality, not the model. He doesn't paint what he sees, he paints the way he wants the canvas to look

and uses the model for reference only.

All of this means that you must have a concept. When you know what you're painting and the idea you want to convey, you'll see properly. Thus, keeping the concept in mind while you're painting will help you see with understanding.

☐ It's not how to paint what you see, but how to *see* what you paint. What you see only with your eyes is not really what's there. We accept too many optical illusions as visual truths.

☐ Seeing in large measure is seeing through a veil of assumptions and prejudices. Learning to paint, if you're serious about it, enables you to understand your conditioning and assumptions and to put them aside. If what you put on your canvas doesn't coincide with reality, then it doesn't reflect your technical ability; it reflects your ability to perceive with clarity.

Don't assume! The way something appears to be is not the only way it can be viewed.

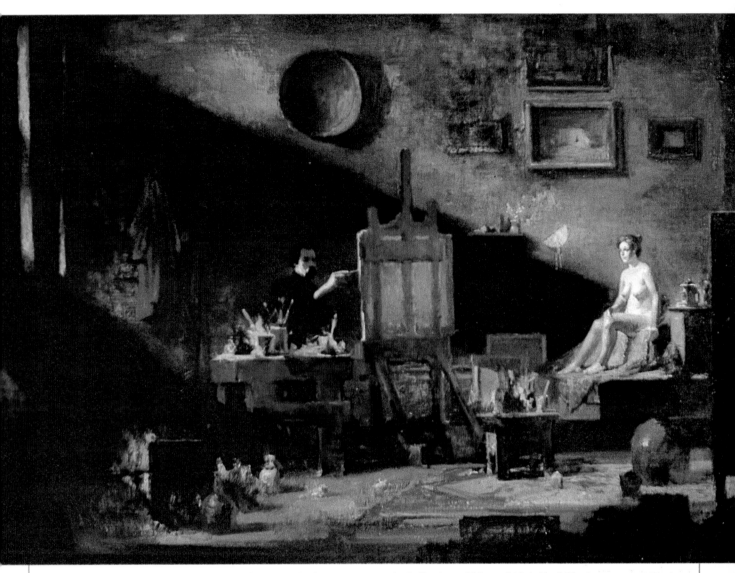

ARTIST AND MODEL *oil, 30″ × 40″ (76.2 × 101.6cm). Collection of Mr. and Mrs. Fred Hogan.*

THE CONCEPT

Before you can learn to paint, you must understand visual concepts and their significance in the structure of painting. Concepts are plans for solving problems of light, air/space, dimension or form, color, value, edges. Concepts involve how the painting will be "read," the value range, the colors that will be used, brushstrokes, *everything*. Portraits, figures, landscapes, still-life objects, are the things used to express or solve the problems.

All great paintings are conceptually simple. Concepts may be ideas about shapes, values, edges, color, or combinations of these. A concept poses a problem and solution for the painting you're about to do. I once said to a friend, "My paintings are about light," and he replied, "I thought they were about quiet."

The idea for a picture comes before you begin to paint. It is the artist's way of seeing things. He abstracts the many small "pieces" before him into a larger, more universal idea. For example, a student will paint anatomy piece by piece, whereas the artist will first paint a piece of light at the value he deems necessary, and *then* put in anatomy to flesh it out. The student paints *things*: the mature artist paints ideas *about* things, or concepts.

Every great painting can be defined as a picture with one essential visual idea. It is what the entire painting is "about." If you decide that your painting will be about the movement of light from left to right, for example, you may choose to use composition, value, and color so that the completed canvas expresses this one visual idea. This way you see your painting in your mind's eye and have a goal to work toward that is the finished painting.

The concept is the essence of your painting but it is extrinsic to your subject matter. The concept is the structure and framework on which your assembled subject matter (composition, value, and color) is suspended, all working to maintain the shape of the original idea of the painting. As you work, you must keep your concept foremost in your mind. It's your matrix.

How Does This Work? Lets suppose you want to paint a portrait that conveys a certain psychological depth of character in your subject. You then think about how you can show this and decide to pitch the entire painting in a low key by using dim lighting. You also decide that by placing the lighting high and to one side, you cast half the face into heavy shadows. You have now worked out your concept and your plan for communicating it, but as you begin to paint, you may also find that certain problems will arise that must be solved.

A problem that frequently occurs in painting portraits in a low key—that is, one having low or dark values throughout—is in maintaining this low-key "look" as you add details or anatomical features. It's easy, for instance, to add the highlight on a nose in too high a value for the lighting, or to create too many value differences on the face in shadow. If you find that the original low-value look of your portrait gets lost as you put in these details, you must find another way to paint it.

One way to avoid making too many value changes as you add details is by making color temperature changes instead. That is, rather than make the highlight on a nose lighter so it stands out, make it cooler—and keep the cool value at the same value as the rest of the nose. Or, make the jawline recede—not by painting it darker, but by making it cooler (add more green or blue to the flesh color). Thus, you preserve the original concept, the low-value look, of the portrait.

If your concept is about light effects, you must structure the value relationships between that light and all the values of the nonlights. The further apart you put your lights and darks, the more drama or depth you'll convey. Light and dark values that are close to each other tend to express an airy or soft quality.

PORTRAIT OF DAVID KRAMER
25" × 20" (63.5 × 50.8cm).
Collection of David Kramer Estate.

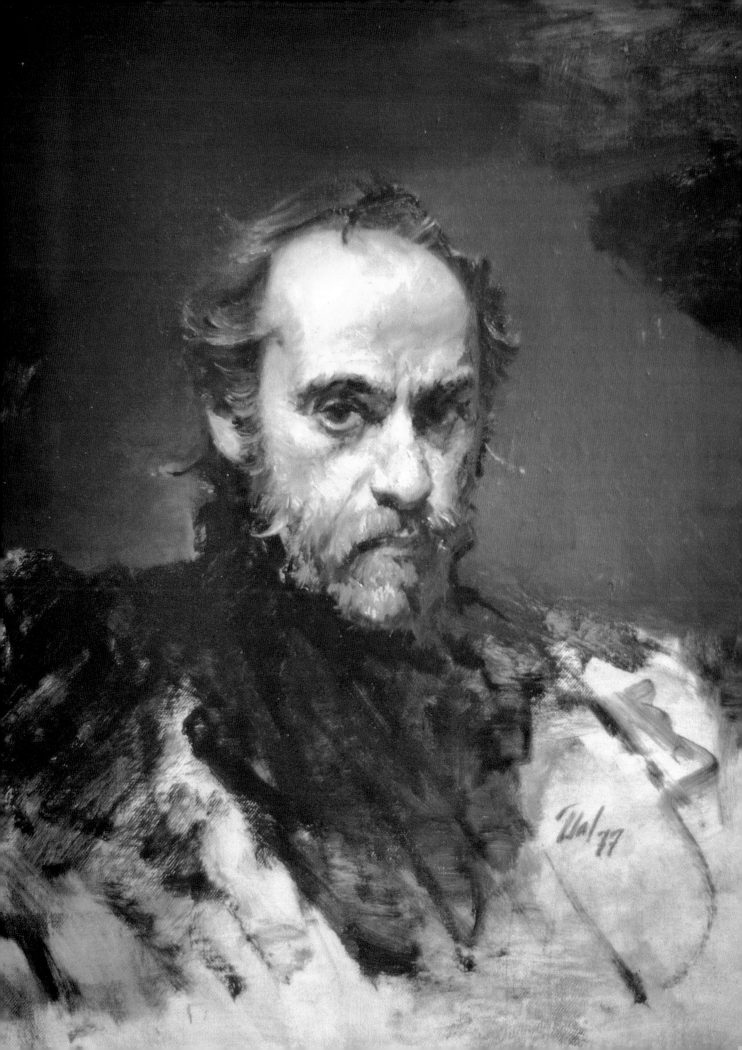

Eye Level and Concept. Arranging a still life and setting up the eye level at which you'll paint it are integral parts of your concept and often dictate it. If the artist's eye is relatively level with the horizon of the picture, he will arrange his objects to read across the picture plane from left to right, or right to left. This is because at this eye level you're not conscious of depth of any consequence. Where the artist's eye level is well above the horizon and depth can be seen very explicitly, the objects will be arranged to convey space. (See *Maroger Pan and Bottle*, page 10.) In a painting about space, the center of interest should be somewhere in the middle or in the background of the painting.

Can you understand how these two concepts, value and light, might be utilized in landscape compositions?

The Importance of Having a Concept. You must have a concept before you can work out a composition for your paintings, just as a writer's theme must precede plot and character. Composition gives substance to a painting's concept, just as a plot and characters express a novel's theme.

To be an artist, you must work with concepts and from a conceptual point of view; that way you'll have a handle on your work that will facilitate the creative process. Working with a concept will keep your techniques under control, because you'll be working within the structure your concept provides—it's the constraint that makes learning possible. You won't be able to go off on a tangent. The concept will

provide consistency throughout your canvas. You'll know the things to emphasize and the things to downplay. It will pull the whole thing together and unify your painting structurally. When you understand your concept as a plan of action, you'll know when your painting is finished, you'll know when to stop. Perhaps the most important thing a concept does is that it enables you to have a sense of what you're doing, what your aim is. Copying is banished.

And, best of all, having a concept gives you a sense of fulfillment when you've completed the painting. You've come to grips with something and have found a solution.

How accomplished you may be as a painter doesn't really matter. Knowing a variety of techniques and showing physical deftness at painting doesn't help you to become an artist. Painters with many years' experience come to my classroom at the Art Students League because they don't know *what* they're doing. They don't feel a sense of accomplishment. They're working without a concept. You have to have an idea beyond the "little pieces" of a painting. There are not parts to reality, just shifts of focus.

If you think of just copying your subject matter accurately, then you're lost. If you're a beginner, you don't think about things that *can't* be copied, so you don't get *any* better. Yet once you start thinking about it, you'll find a way of painting. Think in the right way—a commonsense, utilitarian, functional way. What is it you want to get on canvas?

The most important thing is to think about it.

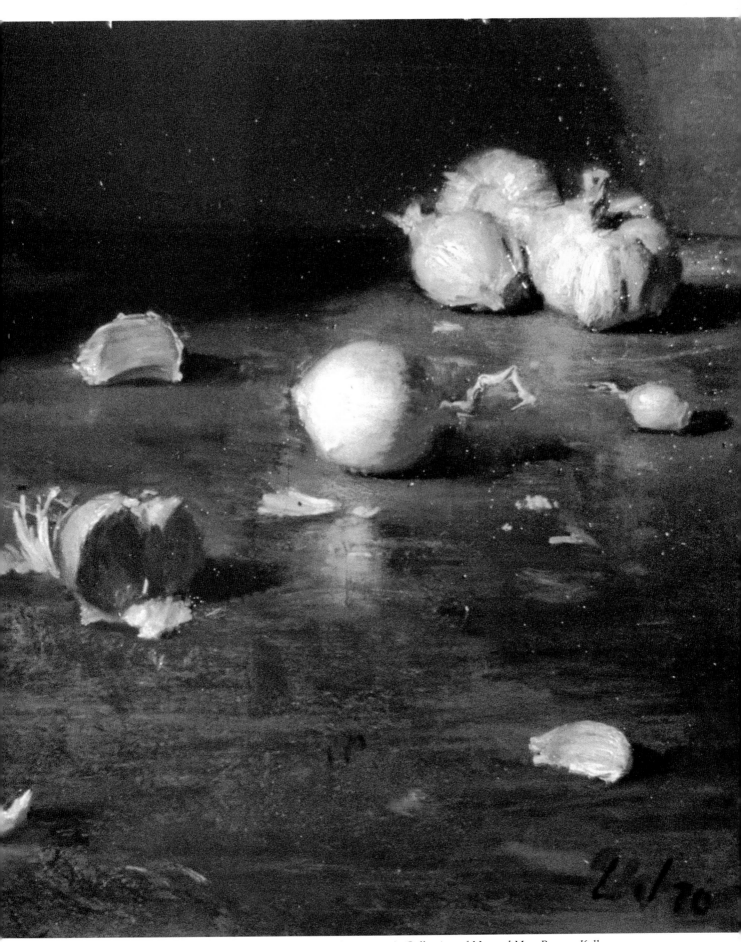

ONIONS AND GARLIC *oil, 11½″ × 13″ (29 × 33cm). Collection of Mr. and Mrs. Ramon Kelley.*

When the Concept is Value.

I wanted to create a certain depth of character and felt that this could be done best by keeping the values in a very narrow tonal range. When doing this, you must be certain that each piece of material, or each shape, retains its integrity.

The light value on the drapery doesn't become so light that it gets confused with the light on her figure.

The background and flesh shadow are similar in value, and the richness of the flesh shadow keeps it separate from the background.

The value range sets the mood, or concept, for this picture.

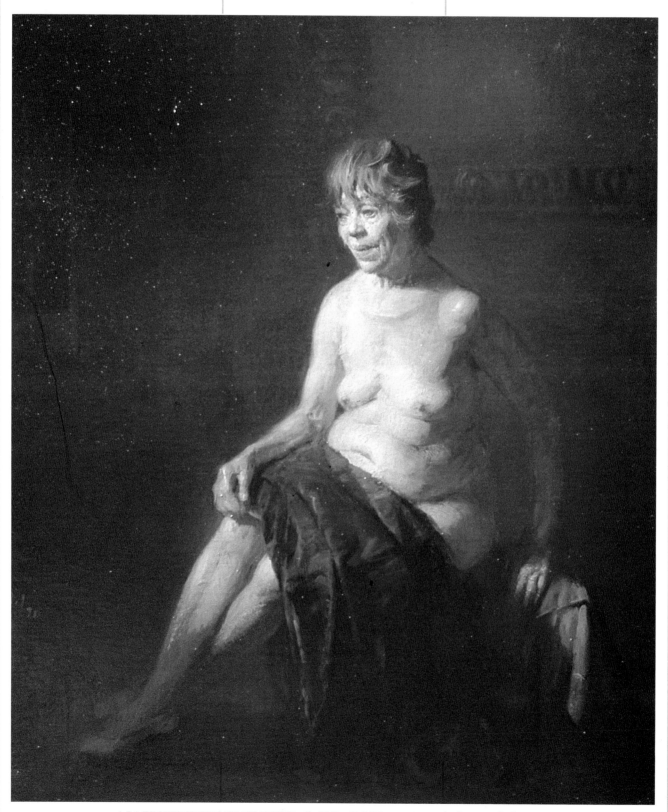

A LA RECHERCHE DE TEMPS PERDU *oil, 29" × 25" (73.6 × 63.5cm). Private Collection.*

When the Concept is Low Value and Light. Mystery and moodiness were part of this sitter's personality. To portray these qualities, I painted a lower (darker) key of values. Everything is in a lower range: darker values of shadows and darker values of light, with occasional small pieces of dramatic highlight.

Remember: The lowest value of the light is lighter than the lightest value of the shadow.

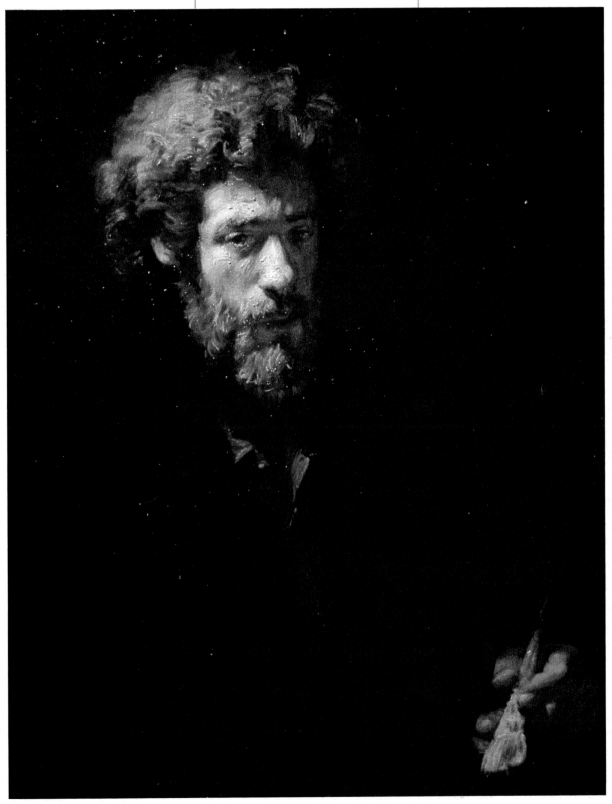

LIONEL, *oil, 18" × 22" (46 × 56 cm), Private collection.*

When the Concept is the Movement of Light. The source of light is on the right-hand side of the canvas and travels from the right to the left. The objects were arranged so that the viewer's eye would follow the light source from the right to the center of interest—the blue vase on the stand at left.

Oddly enough, the viewer's eye tends to go back to the right-hand side, to the ceramic piece and the paint tubes at right. (The human eye prefers to read from left to right.)

STUDIO DEBRIS *oil, 15" × 22" (38 × 50.5cm). Collection of Mr. and Mrs. Walter McDaniel.*

When the Concept is Light and Shadow (Chiaroscuro). The background and the flesh shadow are kept in a close value relationship to create a single foil for the light rising and falling on the face and neck. The light itself has its own tonal range of values.

The background, yarmulke (scull cap), hair, beard, and clothing are all in a very close range. Against that range of values is the light on the face and neck which the viewer is solely conscious of.

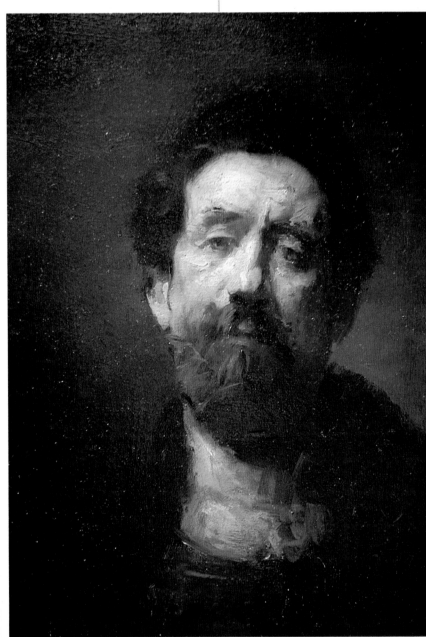

J.H. oil, 20″ × 16″ (51 × 40.5cm). Private Collection.

When the Concept is Color.
All the colors here are grayed, with the exception of the red, and there is a very subtle separation of greens and grays. The apples are a brighter shade of the same green that surrounds them.

The only outstanding color is the spots of red on the apples which, along with the light, also lead the viewer's eye from left to right.

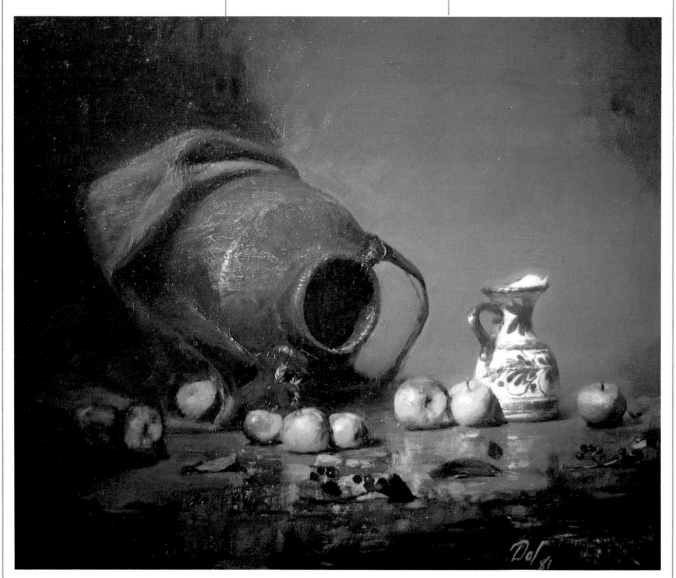

STUDY IN GREEN, GRAYS, AND RED *oil, 18" × 22" (46 × 56cm). Private Collection.*

When the Concept is Color. I wanted to paint in purple; 80% of the canvas is in some shade of purple. The green in the grapes is the complementary color to purple, and the little bit of vermilion on the small vase helps to focus the eye on the center of interest at right.

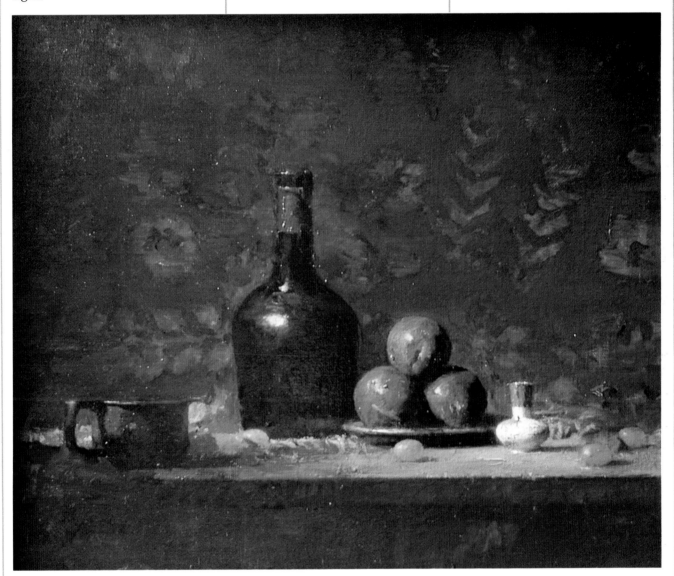

PURPLE, GREEN, AND A LITTLE VERMILLION *oil, 18" × 22" (46 × 56cm). Collection of Tom and Diana Carson.*

When the Concept is Color. Here the two colors were blue-red purple versus green. These two colors are so complementary that they seem in my mind to be the same color.

The green dulls the purples exquisitely and the converse is also true. The impasto, especially on the white peony, adds a dimensional sculptural quality.

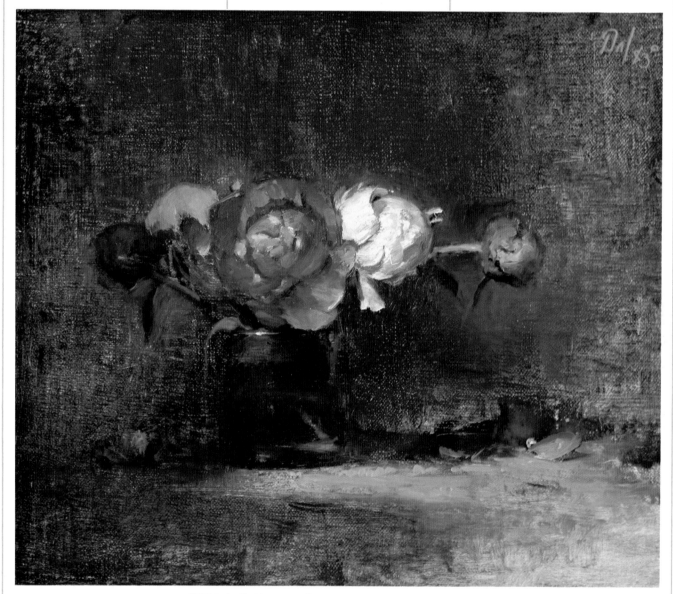

PEONIES *oil, 12" × 14" (30.5 × 35.6cm). Private Collection.*

When the Concept is Color.
The concept behind this painting was to find out how little color could be used without making the painting colorless, and at the same time how much 'empty' space it could stand without it looking empty!

The cantaloupe is the only element that has color. The grapes are black, the background is raw umber. Everything else is a combination of black, raw umber, cobalt blue, and Naples yellow. Thus, whatever color is there (the cantaloupe, that is), has much more intensity.

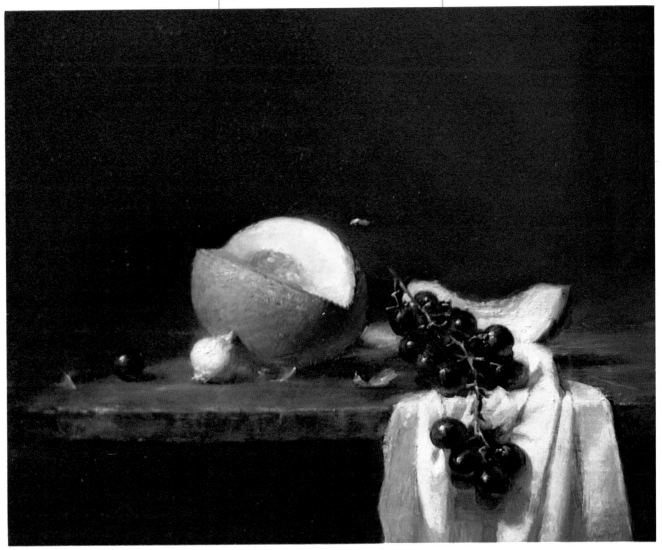

COMPOSITION IN RAW UMBER AND ORANGE *oil, 14" × 16" (35.6 × 40.6cm). Private Collection.*

When the Concept is Color. One way to do a still life is to use as little color as possible throughout the canvas and reserve your vivid colors for the center of interest. It's a question of color vs. color-lessness. If you're doing peaches and an apple, for example, paint the fruit with the light hitting it and use all your color *there*. This approach illustrates that you don't have to paint every inch of canvas with a lot of color.

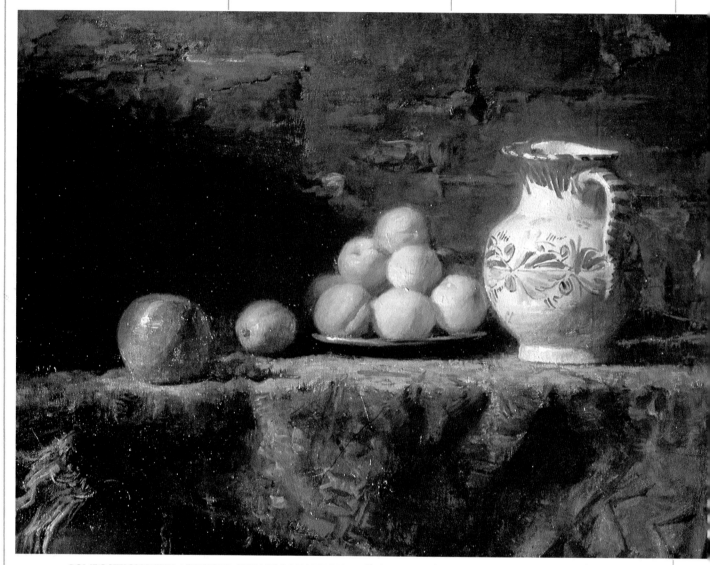

COMPOSITION WITH APRICOTS AND MEXICAN PITCHER *oil, 20" × 23" (50.8 × 58.4cm). Private Collection.*

When the Concept is Intensity.
This painting is a simple arrangement of light and color, and of a little bit of color against a lot of colorlessness. The little bit of orange-yellow color in the peaches brings the whole painting to a focal point.

Though it may not look it, the light here has no particular color. What makes it look colorful is its crispness. Anything crisp will convey a feeling of color.

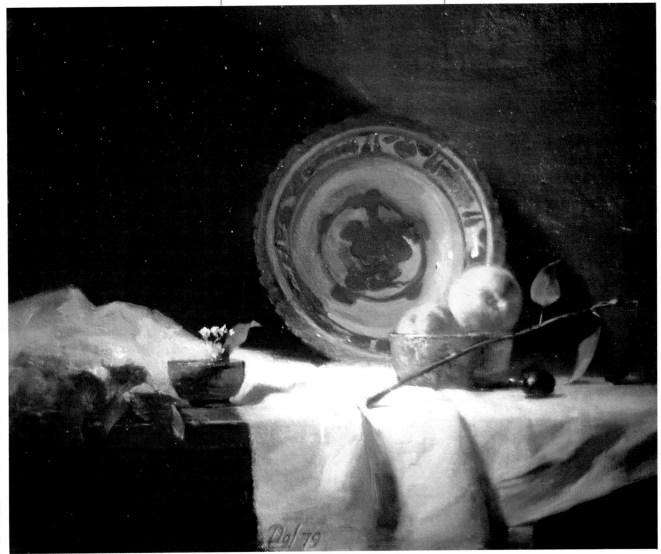

STILL LIFE WITH PURPLE AND GREEN *oil, 14″ × 17″ (35.5 × 43cm). Private Collection.*

When the Concept is Shape.
You can't have shapes without having value contrast and once you have value contrast, you have shapes. You must be aware of the shapes of value.

This painting shows dark shapes against light on the hands, for example, the dark underside of the two fingers of the right hand against the light.

On the left hand, notice the pattern of light with a little bit of dark going down the middle.

What interested me was the abstract shapes of the light areas and the shapes of the darks, which are the major values here. Notice that they are very simple shapes.

There are slight variations of value within the light shapes, but not enough to break up the shapes.

The darks and lights on the hands keep them isolated from the background which is another value shape.

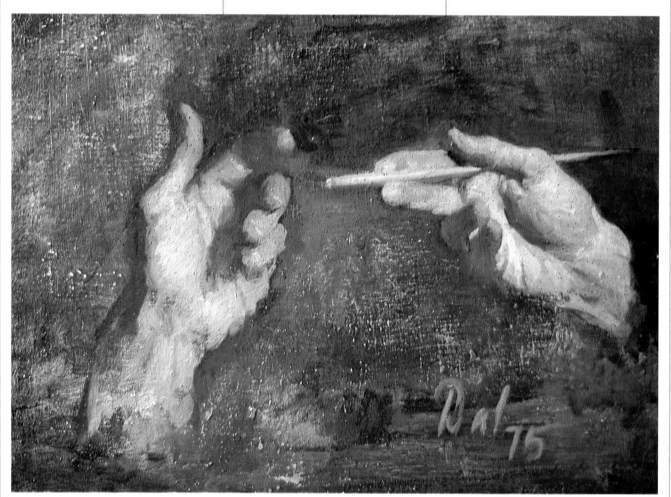

MY HANDS *oil, 15" × 20" (38 × 51cm). Courtesy of O'Brien's Art Emporium, Scottsdale, Arizona.*

When the Concept is Edges.
This self-portrait lent itself ideally to the study of edges. Remember, each beginning has a crisp edge. When the light hits a form, it has a crisp or hard edge. As the form starts to turn away from the light into shadow, there's a soft edge, or transition, between the light and shadow, then the form ends with a crisp or hard edge; a new light begins and the sequence is repeated. A soft edge will follow a hard edge and a hard edge will follow a soft edge.

In this self-portrait we can follow one sequence of light at the sideburn and see how the light travels over the eye where the edge gets softer till the sequence ends at the cast shadow on the bone of the nose.

All of the features, eyes, nose, mouth, all the little tucks and folds on the face, all follow that same sequence or design.

See if you can follow other sequences of hard and soft edges in this self-portrait.

If you understand this sequence of light, you can design a whole painting even if you're far from the model and can't see well.

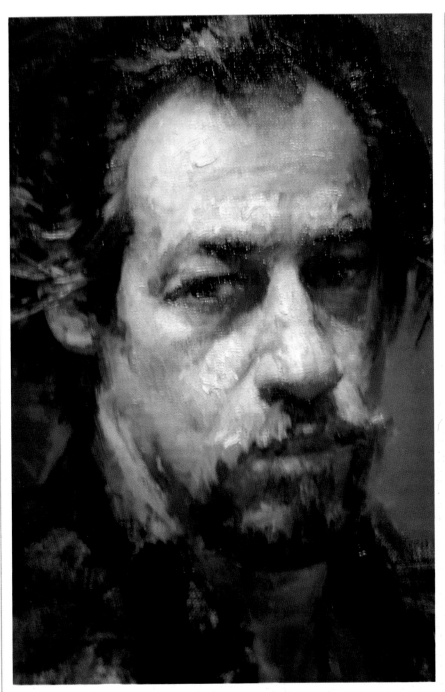

SELF PORTRAIT *oil, 24" × 20" (61 × 51cm). Collection of Dr. and Mrs. Marvin Kantor.*

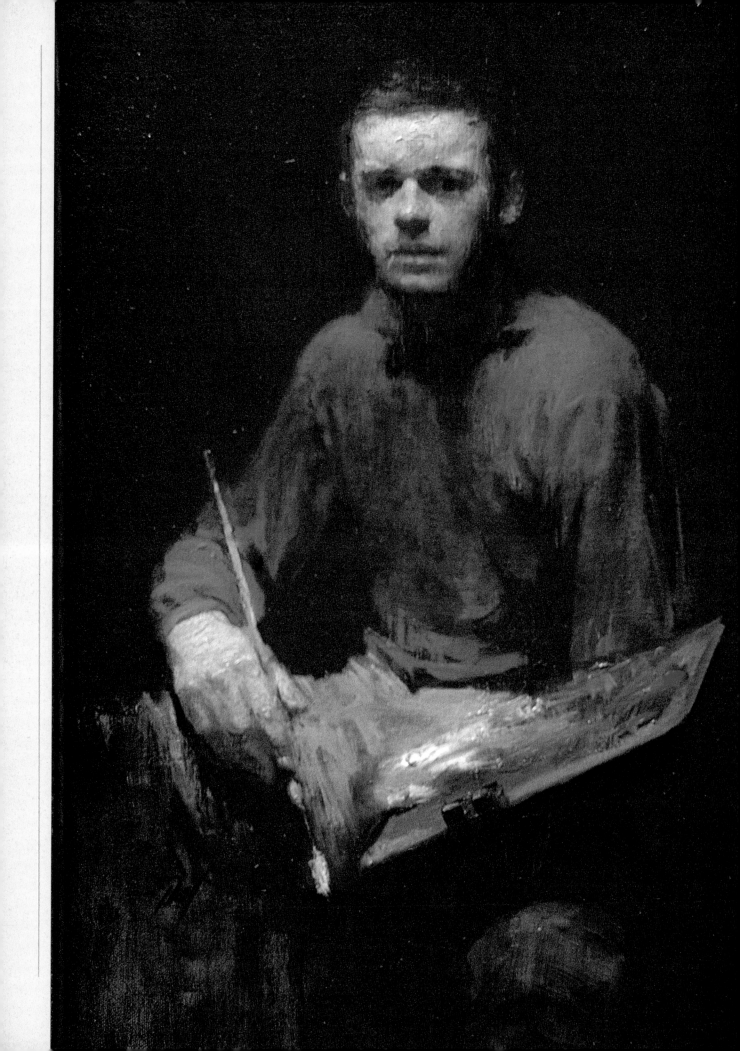

PART TWO
PAINTING PROCESS

THE ARTIST
oil, 22" × 16" (55.9 × 40.6cm).
Private Collection.

MATERIALS

The Palette

☐ In preparing your palette, lay out all your colors and mix each color with a little medium to get the consistency you want. This procedure prepares *you* also since it psychologically warms you up for painting. Medium keeps paint from getting too stiff—you may want to use even more medium as you work. Out of the tube, paint is "short" or "stiff." When mixed with medium, it becomes "long." Put enough medium in each color until the paint almost has a consistency of mayonnaise or sour cream.

Suggested Palette and Arrangement

1. Naples Yellow
2. Yellow Ochre
3. Terra Rosa or Venetian Red
4. Cadmium Yellow Deep
5. Cadmium Yellow Light
6. Cadmium Red Light
7. Cobalt Blue
8. Ultramarine Blue
9. Burnt Umber
10. Ivory Black
11. Flake White

Optional: Rose Madder (for glazing)

Brushes: Grumbacher's Degas series (filberts) #3, 5, 6, 7

Medium: Copal Painting Medium—Heavy *or* Maroger medium *or* stand oil (for a thicker look)

Brushes

☐ Use bristle brushes that resist the canvas and have some spring. Filberts have the most versatility.

☐ During a painting session, avoid washing your brushes in solvents (turpentine, for example). Instead, wipe the paint off your brushes on paper towels before you use them again.

☐ If you have to leave your painting to go out for lunch, it's better to leave the paint on the brush than dip it in turpentine. Turpentine dries out your brushes and it burns the bristles. When you've finished for the day, clean your brushes with turpentine and wash each one out with soap. Be sure to wash out all the turpentine.

☐ If the bristles on a brush lose their shape, wash the brush in soap and water. After it's dry dip it in milk to get it back into shape. Gently shape the wet tip with your fingers and let it dry for a day or two. It may help.

Note: Palette is turned on its side. The white is actually on the bottom, with the warm colors at left and the cool colors running along the top.

COMPOSITION WITH PAINT BRUSHES *oil, 18" × 22" (45.7 × 55.9cm).*

Canvas

☐ It is generally easier to use a neutral-toned canvas and a toned palette. Raw or burnt umber with cobalt or ultramarine blue are good for toning a canvas. White canvas doesn't work well because you can't see accurate color or value relationships against the stark white. On a toned canvas, lights and darks, as well as colors, show up immediately. Toned canvases also look bigger than white ones.

☐ If your canvas has a good smooth surface and if you don't work the paint too much, the paint should stay on top of the canvas and remain shiny, rather than sink in and look dull. I prefer a smooth canvas that allows you to move the paint around a bit.

☐ Most store-bought canvases have a gesso ground. But I prefer to buy an untreated canvas and prepare my own grounds. I use a rabbit-skin glue/white lead ground, with a little Maroger medium added to the second coat.

☐ When painting on Masonite instead of canvas, you may find the surface too absorbent and the paint may sink into the surface. To avoid this, apply your painting medium with some umber to the board a few days before you start to paint on it.

☐ As you begin work on a canvas, start with an impression in your mind and sketch this quickly. Then go back and do the pieces. For example, lay in the whole body first and then go back and put in the anatomy.

Mediums

☐ Maroger is a medium that I add to my paint colors to give them a consistency I work comfortably with. The word itself is the name of a French restorer of paintings, Jacques Maroger, who formulated this medium from cold-pressed linseed oil, litharge, and mastic varnish.

☐ There are several other mediums or gels that one can use to mix with tube paints. Some dry very slowly and some dry very fast, almost within the hour. Maroger medium dries overnight.

☐ If a painting in progress has dried and the colors have become lifeless, put some medium on the painting to bring the color back to what it was. Brush it on back and forth over the entire painting.

Miscellaneous Advice

☐ Hide glue, available in hardware stores, can be used to glue canvas to board or Masonite. This glue dries faster than most other glues.

☐ Varnish equalizes the surface of a painting so that there are no matte and glossy areas and it also keeps dirt off the paint. If you apply varnish after a picture is completed, apply it either right away so it can dry along with the paint, or wait until your painting is completely dry. If you apply the varnish before your paint is dry, the drying paint will crack the varnish.

☐ Paintings get darker if you store them in the dark and lighter if you store them in the light. Light bleaches the linseed oil in the color.

☐ In carrying two or more paintings, if you want to keep them separate, insert wax paper between them. The wax on the paper keeps them from sticking together.

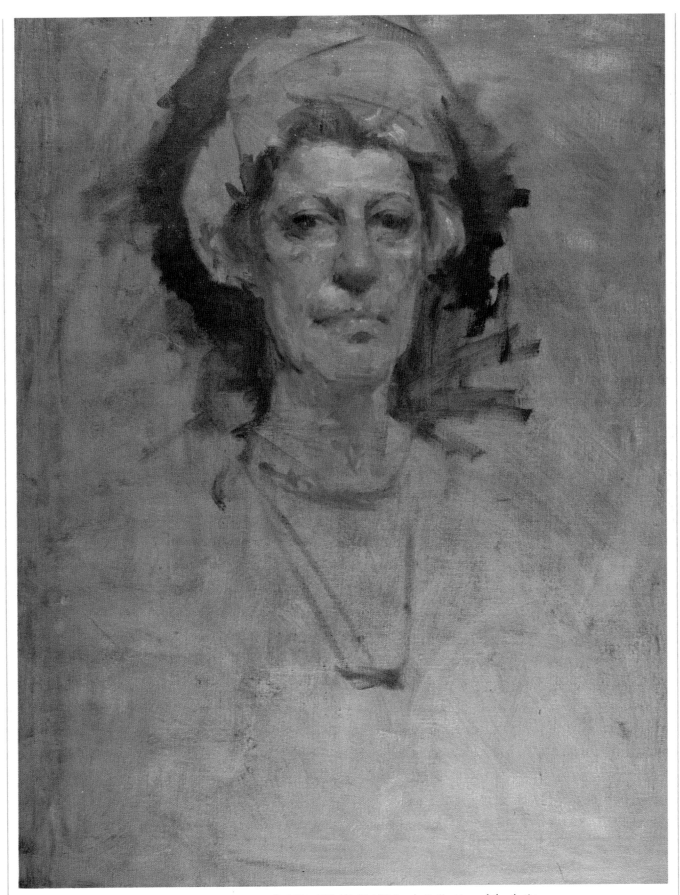

THE ARTIST'S MOTHER *oil, 25″ × 20″ (63.5 × 50.8cm). Collection of the Artist.*

BRUSHSTROKE TECHNIQUES

An important lesson in painting is to learn the feel of the paint on the brush, to know how much paint is needed for a thick or thin application of color. The thicker the paint, the richer the darks, and the lighter the lights. Learn to hold a brush loaded with paint and still make a sensitive stroke so almost no paint comes off. If you aren't in *total* command of your brush and paint, you are not a painter. This is primary; trying to learn value and color is otherwise impossible.

Practice, while painting, to control the amount of paint that comes off the end of your brush. *This is the heart and soul of painting.*

Make each brushstroke describe your intention. Think before you use the brush. Load your brush with thick paint and let the brushstroke follow the form of the object you're painting, or stroke it on in the direction of the gesture, the body's movement. You might use the brush in a chiseling fashion, in short staccato movements, or as a conductor uses a baton. Always use the stroke that best describes the surface you're painting. And finish your brushstroke on the canvas. Don't lift the brush until the stroke is finished. Then lift it off for the next brushstroke to begin and end.

Start to paint seriously the moment you pick up a brush. If you begin by painting carelessly, with slapdash strokes, you'll find it difficult to move into more careful painting.

☐ Use more impasto, that is, thickly applied paint, where the center of interest lies. Impasto breaks the surface of the canvas and gives it more thrust. You can't get thrust without the impasto. It can also bring life to a dull color or area in your painting.

☐ As you paint, don't scrub the paint into the canvas. Be sure your brush has plenty of paint, apply it, and *let it stay*. If necessary, you may push the paint around a bit, up, or in a curve, gently. There should be a layer of paint between the brush and the canvas. You might say the bristles never touch the surface.

☐ You can mix colors on your canvas as well as on your palette.

☐ When you paint, the brush should make no noise. Pick up enough paint so that it works silently. In other words, keep a layer of paint between the brush and the canvas.

If you paint thinly, use enough medium to attain a silent brush.

☐ With each paint application, with each stroke, do the "finished" picture. Otherwise, all those brushstrokes you weren't paying attention to will come back and haunt you.

☐ Nothing delights a student more than to *draw* with a paintbrush—the more minute the detail, the better. Avoid doing this. Instead, *paint* with your brush; think in terms of dimension. Instead of drawing individual hairs, for example, paint hair thickness or dimension; paint the light on the hair.

☐ If too much canvas texture is visible through your paint, you will have a colored canvas, not a painting.

☐ Have the best materials available, especially brushes. You want a brush that will do *exactly* what you want it to do, instantly.

☐ A "mistake" done with a crisp, confident brushstroke will look better than something correct done with a flaccid brushstroke.

☐ There are two essential types of brushstrokes, one to create form, the other, direction. The stroke that goes along the form gives action and direction. The stroke that traverses or is painted across the form gives instant dimension. The choice of brushstroke should be part of the painting process.

☐ A juicy brushstroke (one with lots of paint on it) makes an enormous difference in adding a dimensional quality to your painting.

☐ Never do more than three strokes with the paint on your brush. Two strokes are better. Then pick up another batch of paint for each new series of brushstrokes.

☐ Respond to the tactile surface quality of what you're painting with your brushstrokes. For example, different fruit has different textures; oranges differ from apples. What you paint dictates how you paint it.

☐ Whatever brushstrokes you apply to your picture, make them describe something. A stroke may describe space, dimension, movement, light, color. Try to get as much of this descriptive material as possible into your picture.

☐ Paint broadly with heavy paint. Keep yourself from merely dabbing. Be more painterly.

☐ You can get rid of choppy brushstrokes in the background by taking a big brush and painting in one direction, horizontally. After you finish, take a dry brush, lay the flat side parallel to the canvas and brush lightly downward.

SELF PORTRAIT *1984 oil, 16" × 14" (40.6 × 35.5cm). Private Collection.*

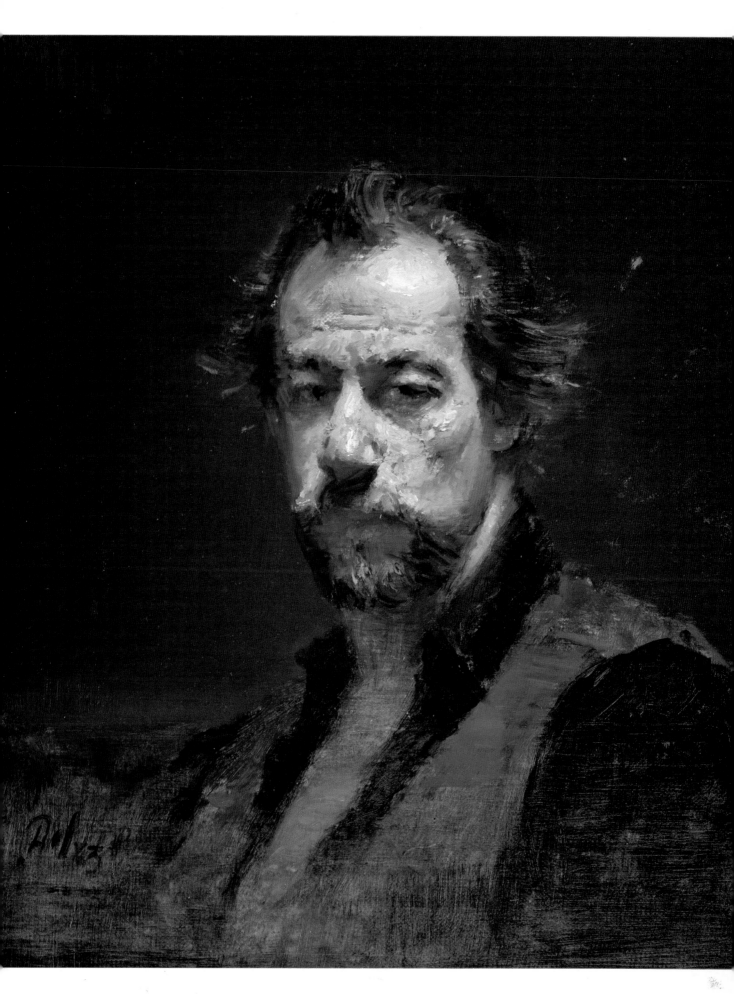

CHIAROSCURO

1.

"Chiaroscuro" literally means "light/dark." In chiaroscuro painting, your eye follows the light. The light gives the picture its flow—it takes the eye from one place to another, and the shadows structure the painting.

In a still life, there are two basic views an artist can work from. One is the shallow picture plane where objects are placed across the canvas from left to right, or right to left. The other is the tipped picture plane where objects go *into* the picture, at a variety of angles or curves, portraying depth.

When the picture plane is at eye level or close to it, the most important element, or the center of interest, is placed at the right. With the artist working from dark at the left to light at the right, the picture culminates at the right. Seeing thus from left to right is the universal human way.

As you begin, first place the center of interest, which lies at the right. Everything will lead up to this. Paint this focal point clearly, with enough tone and mass to be seen precisely, whether it be a jar, orange, or whatever. To be worthy of interest, the focal point must have enough light, color, texture, and substance to excite and capture attention. To keep the eye—which has followed the light to the right—from going *beyond* the edge, use a stopper. The stopper may be a shadow on a fruit peel, or a lone grape. It will hold the eye and keep it from traveling further.

☐ In setting up a still life, you'll create more interest if all the objects do not have light on them. It also helps to have an object darker than the background.

If something looks dark and you want to lighten it, see how much light you can put in an adjacent area.

A Chiaroscuro Still Life. Let's imagine a typical setting: an amber glass at the left, five nectarines in a group, and a small blue and white Mexican pitcher as the center of interest on the right. The light comes in gradually from the left to focus on the pitcher at the right. The background is dark; the light on the objects becomes gradually brighter as it goes toward the right where it bursts into full intensity.

1. Begin with the darkest dark first: the amber glass. Use a lighter shadow color for the background.

2. Next, place the shadow on the nectarines. Make the shadow here a bit lighter than the shadow on the glass. Then paint the shadow on the pitcher at right. Use the same shadow value as on the nectarines. Up to now, only darks have been painted.

3. Keep the background soft and shadowy. Use a cadmium color to provide transparency. The glass in the shadow area should be somewhat soft-edged.

4. On the first nectarine (from left to right), paint a little bit of light, with the edge in shadow, to create the illusion of form. On the second fruit, a bit more light than the first one; and on the next, more light still and brighter than the previous one. In other words, we are painting a progression of values.

In chiaroscuro painting, one way to make an object light is to paint the surrounding area in a lighter tone, not darker. It's like placing a little halo around it.

Out of the darkness at the left, the light travels across the picture plane. This light, striking the pitcher, also hits the surface before it. As each item gets closer to the pitcher, it should be more luminous.

4.

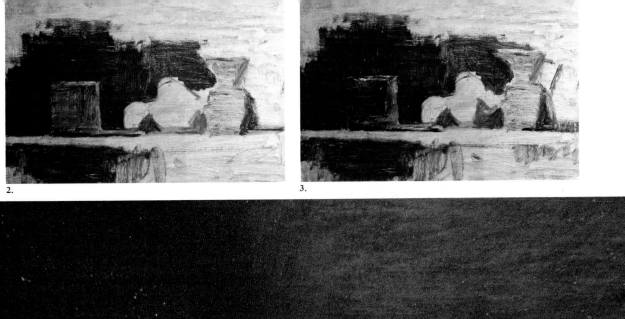

2.

3.

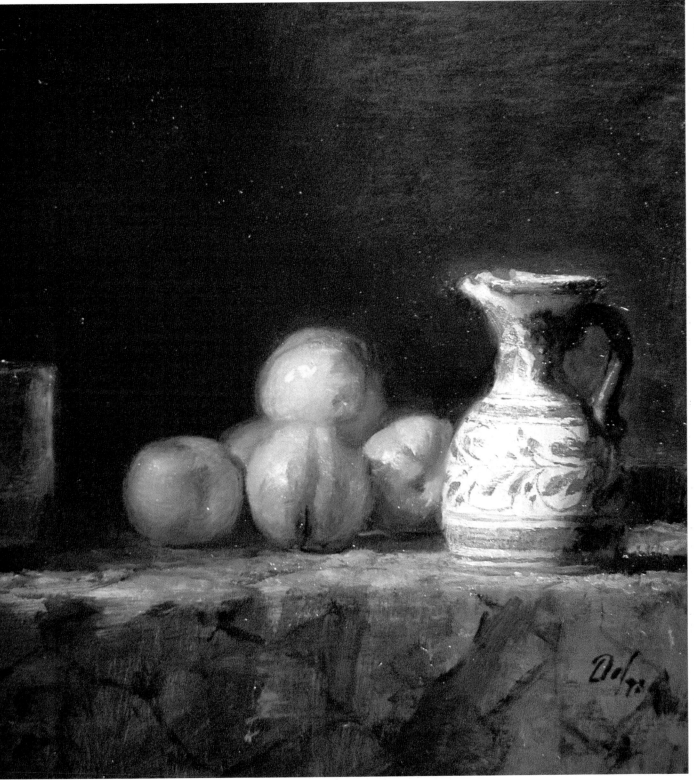

STILL LIFE WITH NECTARINES *oil, 12″ × 16½″ (30.5 × 41cm). Collection of Dr. and Mrs. William Horowitz.*

PAINTING PROCEDURES

Painting a Grape

1. Lay in the entire grape with a little ivory black and cadmium red.

2. Paint the cast shadow.

3. Use rose madder and cadmium yellow to pick up any transmitted light.

4. Apply a cool highlight and model the tail a bit with the back of a brush.

Turn Your Grape Into a Cherry. Sir Joshua Reynolds stated that Rubens was able to see the distinguishing characteristics by which each object is known. The essential difference between a grape and a cherry is the grape's semitranslucency; light passes through it (see step 3). If you darken the shadow to give it a denser look, and slightly modify the cadmium red in the light, you'll create the illusion of a cherry instead of a grape.

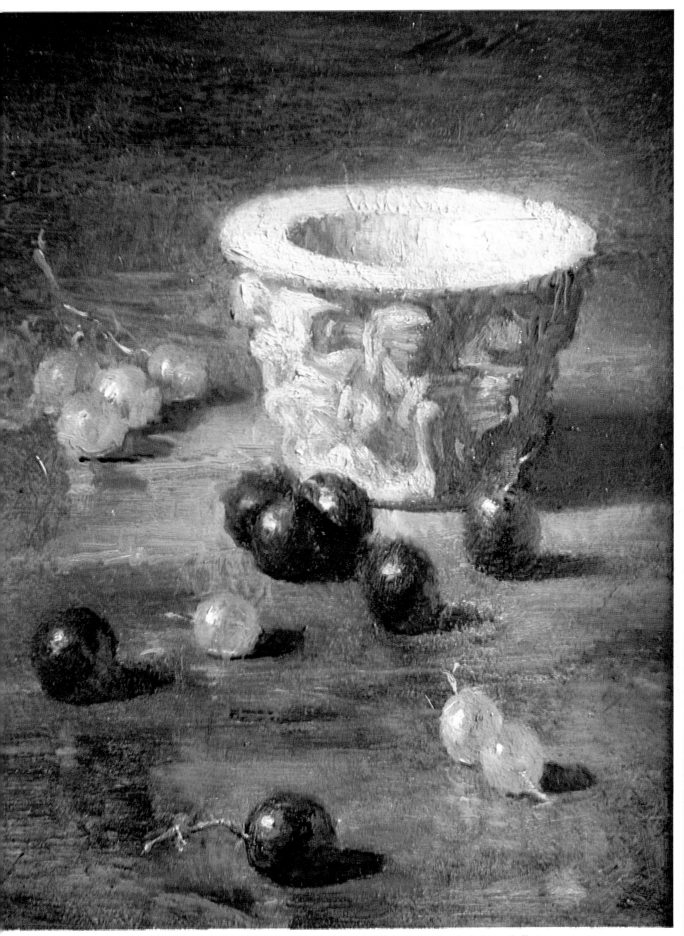

CEREMONIAL URN WITH GRAPES *oil, 12″ × 10″ (30.5 × 25.4cm). Private Collection.*

MASSING

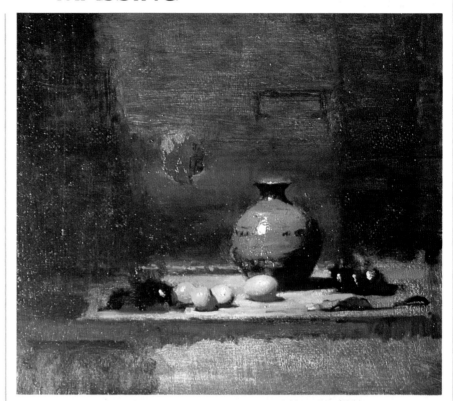

Try to see your subject as a whole rather than in terms of its details. The way to do that is by massing individual details into flat planes of a single value and color. For example, you should see an apple as two planes, a light plane and a shadow plane; and you can do the same for a head. Later you can put in the smaller details, the stem of the apple or the nostril or eyebrow, but don't get involved too early with these minor details.

You must see the entire painting as a whole, too, and not just as separate objects. Massing gives you a feeling of bulk or weight, a three-dimensional quality, whereas outlining contours gives a flat, two-dimensional effect.

Massing also starts you thinking early on about the concept of your painting, because the way you shape your masses and where you position them, where on the canvas you decide to put your strongest lights or your deep shadows, for example, is part of the "look" or conception of your painting. When all your broad masses or planes are in position, you can put in smaller forms, painting small shadows or lights, or softening your edges into a light area to show, say, how the side of the face meets the chin. You are always working from the larger to the smaller, from the whole to the specific, as you put down information in increasingly smaller areas.

☐ Think in terms of planes, mass, dimension, rather than line and shading. The only way to start is by creating a mass. Mass gives you a better idea of size than a line drawing. You need one mass (an object, say) against another mass (space).

To see how massing works, let's see how to paint grapes. Mass a whole cluster, rather than start with individual grapes. Do a mass for the shadow, another

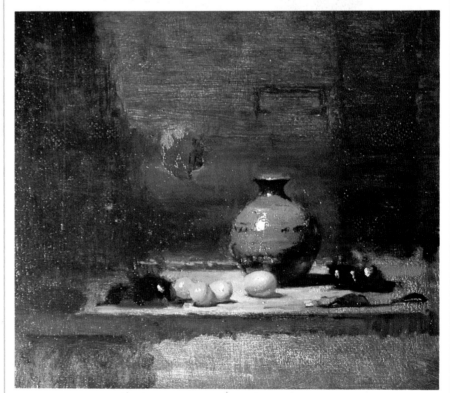

mass for the light. Then you can begin to suggest individual grapes. (See *Pear and Grapes*, page 49.)

☐ By drawing masses, you get a better sense of proportion.

☐ A mass of shadow and a mass of light give your painting dimension.

Painting Shadows. Start painting your shadows first because they give you the feeling of structure. Shadows keep the composition in place. They're like the bass and rhythm in music.

1. In painting an object, mass the shadow on the object and the shadow cast by it together. Paint both shadows as one shape.

2. After massing, do your shadows, then add a little more cadmium color into the shadows to get them a little richer.

Thus, slowly, from a rough start, you get into actual color and paint. Up to now the picture has just dark masses and shadows.

Drawing Reflections

1. Mass shadows and cast shadows of objects.

2. Break up shadows by adding reflected light. Lift them out of the drawing with a kneaded eraser.

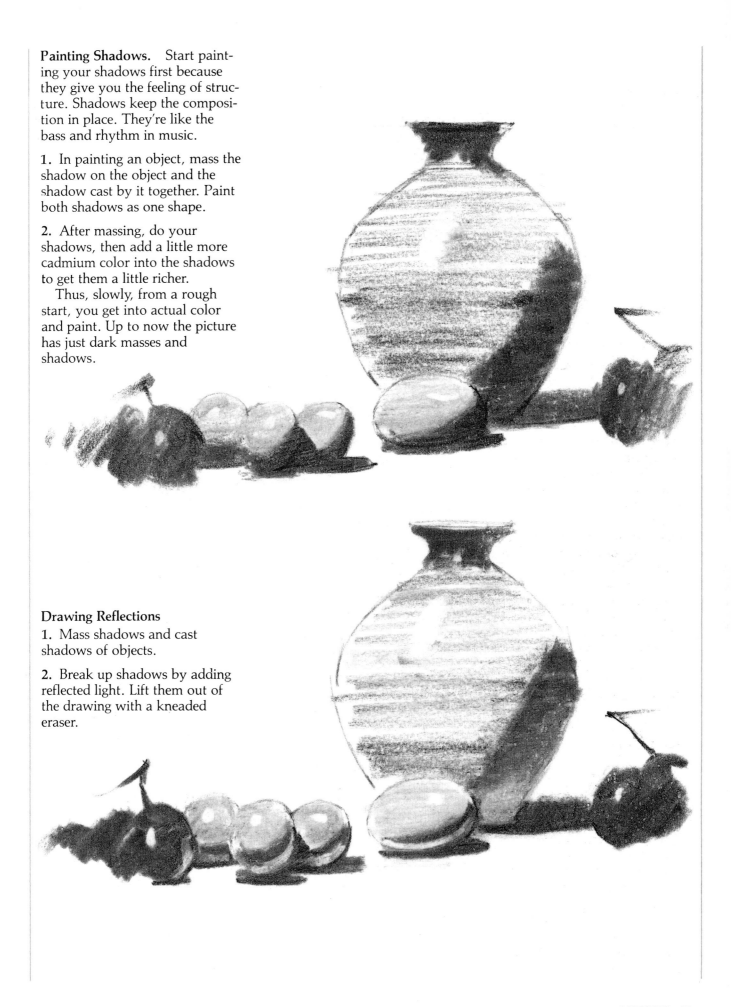

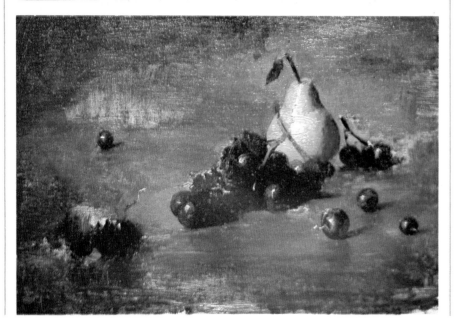

Developing the Concept by Massing. The four stages shown here illustrate how the concept was realized in the painting *Pear and Grapes*. In the final painting nothing is changed from the original concept; it is merely embellished and elaborated upon.

1. My concept, or idea, for the painting was movement through space. I tried to create this sense of space and movement in a still life, by arranging the fruit to lead the eye from one space to another. I wanted a diagonal movement and arranged my objects accordingly, starting in the lower left-hand edge of the canvas, leading to somewhere in the upper right-hand corner, always remaining conscious of the size and placement of the objects. Notice that the grapes are treated broadly, as a mass.

2. From a general conceptual idea, objects are made more specific. I introduce some counterpoint—the use of contrast and interplay of elements—by means of two grapes, one large one toward the lower right and the other at the upper left. The pear, as the strongest element, would hold its own as the actual center of interest.

3. I elaborate, transforming the lump of dark mass into more specific grapes; and arrange highlights on grapes to form a melodic line, being selective about the brightness and dullness of the highlights which helps to evoke a melodic feeling. Some grapes remain as a mass.

4. Note that the grapes in the foreground where the diagonal movement begins are still fairly generalized and the remaining grapes are built up more specifically. The light on the pear, the center of interest, is raised in value, and a grape stem leads you to the pear.

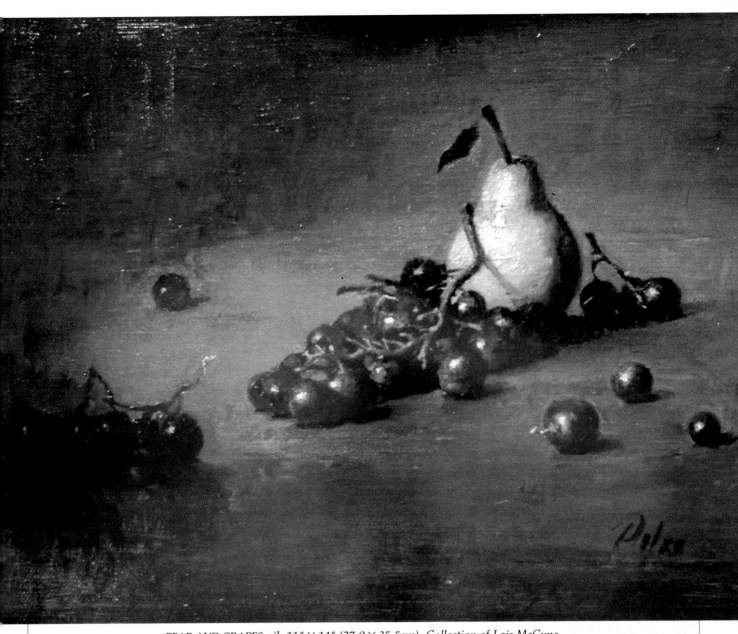

PEAR AND GRAPES *oil, 11″ × 14″ (27.9 × 35.5cm). Collection of Lois McCune.*

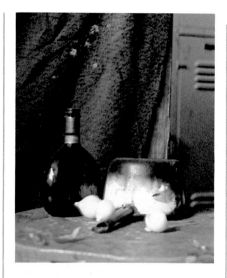

1.

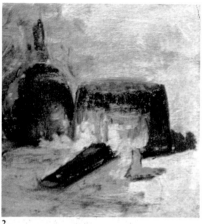

2.

3.

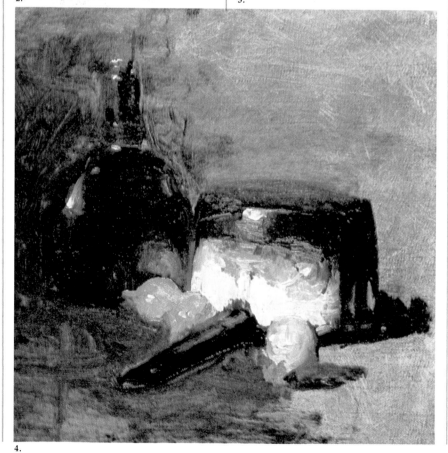

4.

Another Example of Massing.
The photograph shows the actual setup for this still-life demonstration. My concept was to portray a "reverse C" type of movement through space rather than movement in a straight line as in *Pear and Grapes*. The setup is placed below eye level so you can see considerable movement. The onion peel in the lower left edge of the setup is very important since it begins the "reverse C" movement. The white of the onion against the white of the Maroger pan (a pan I use for making painting medium) makes one unit. This area is the focal point. What further engages the eye is the texture and color of the overflowed medium below the rim.

1. Here I started massing in the main elements of the composition.

2. As soon as I could, I began getting into the elements of the finished painting. I introduced color (burnt umber and phthalo blue) and highlights on the bottle. I used ivory black and cadmium yellow medium and a little cadmium yellow deep to create the green-black of the bottle.

3. I carved the objects out of the background and refined the shapes.

4. I continued fleshing out the concept by adding the other elements of the painting.

Detail. To create the two onions at left, I started with one shape and divided it into two. Note that the reflection of the onion in the bottle is in a low value appropriate to the bottle.

MAROGER PAN AND BOTTLE *oil,*
21" × 18" (53.3 × 45.7cm).
Collection of the Artist.

Massing Features

1. Start with a mass for the head, not a line drawing. Mass will give you a better idea of size. Mass is bulk, a quantity of matter adhering together to make one body.

Do not think of drawing in linear terms. There should be no finesses now.

2. Fill in your canvas. Put in shadow, the underplane of the nose, the shape of the eye socket. Get your eye and nose relationship, the shadow under the chin.

3. To do the nose, mass in the eye sockets and the shadow plane and the cast shadow under the nose, and you have the nose. There's no need to emphasize the sides of the nose.

4. Try horizontal brushstrokes across the face rather than vertical ones.

BOB PALEVITZ
oil, 19" × 17" (48.3 × 43cm).
Collection of the Artist.

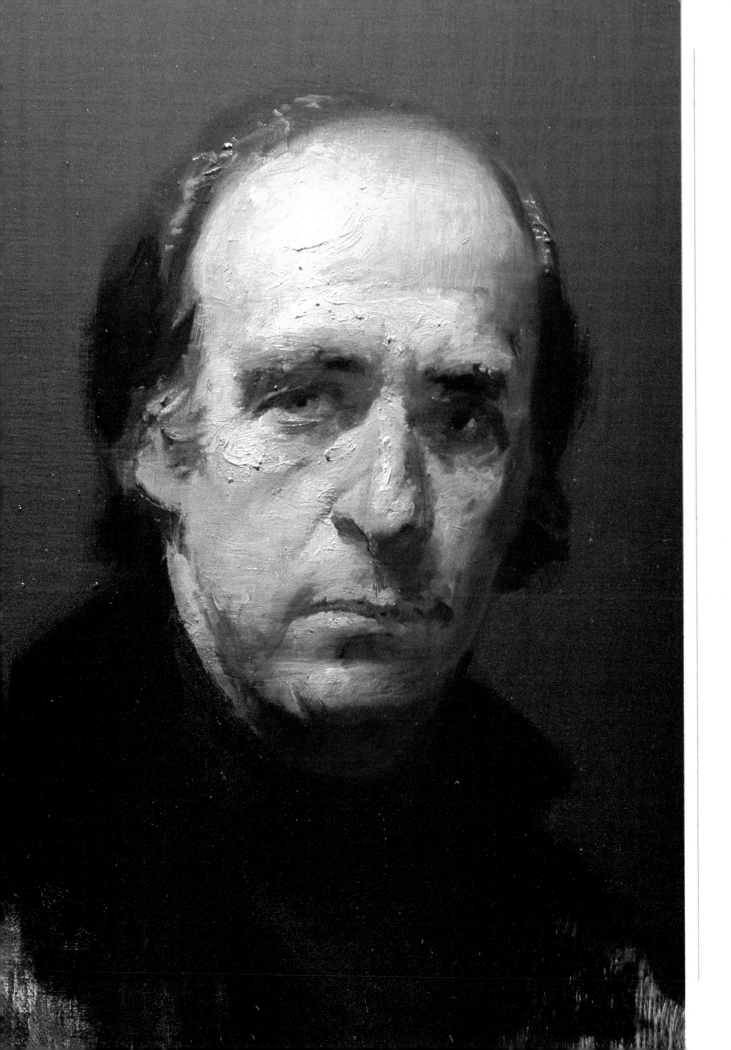

Sculpting on Canvas. Paint an abstraction, a shape or color, and then make it whatever it has to be—an arm, hand, knee.

1. Starting from the head and going to the torso, the gesture (the pose itself) is the all-important thing. Do the gesture in broad strokes.

2. Painting is like sculpture. When painting an object, you're not painting roundness but the illusion of *dimension*.

3. Use light to make form come forward—the nose, breasts, thighs.

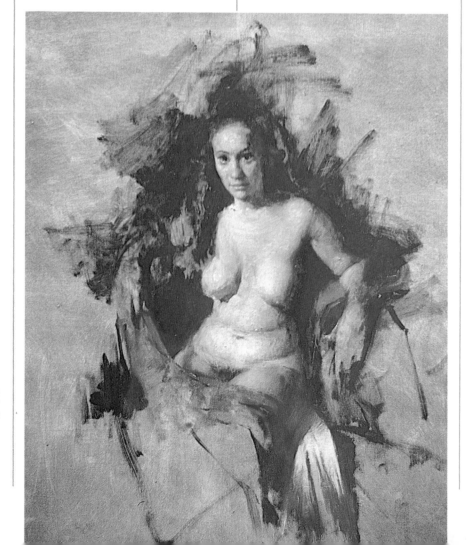

4. A shadow on the stomach should follow the swell of the stomach. It should not be painted straight across the abdomen at an angle.

EMERGING NUDE
*oil, 30" × 23" (76.2 × 58.4cm).
Collection of William Macomber.*

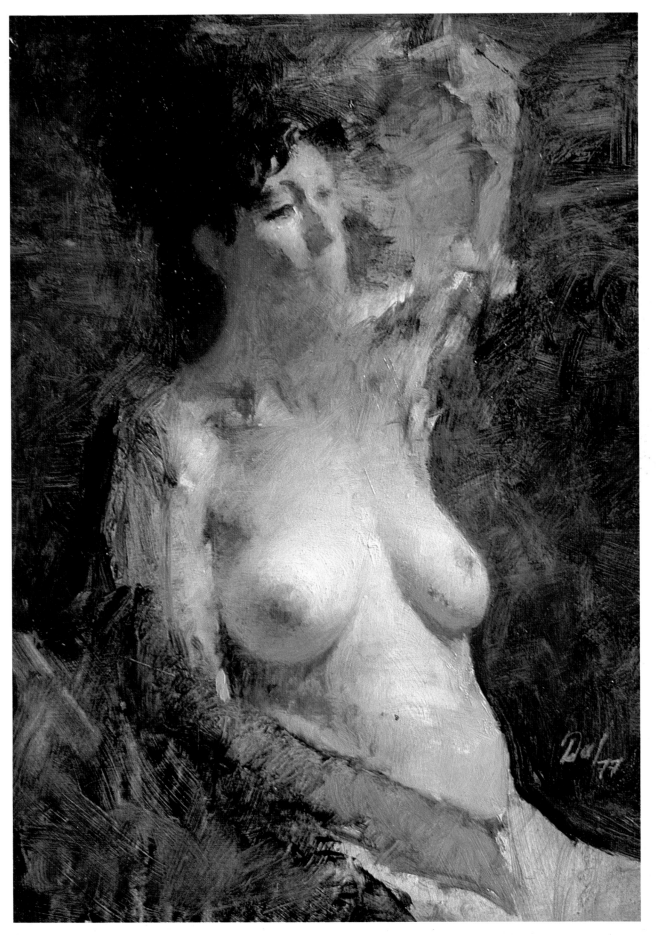

DOLORES *oil panel, 9" × 12" (23 × 30.5cm). Private Collection.*

PLANES

Planes of the Head. After you've done the background and massed in the hair and the shadow, start painting the lights into your portrait. In doing the lights, paint the planes of the face: the frontal plane of the forehead, then the sides, the frontal plane of the face (the cheeks), the sides, and so on. Emphasize them.

If both sides of the face are in light, work them together. Apply color to one side, and immediately after, to the other side. Apply the same color; value can come later. Keep the color, as well as the drawing, symmetrical.

Keep the relationships of the face in mind as you paint. Follow through on them: If you put gray on one cheek, put gray on the other. Work coherently with your brush and tie the similar planes of the face together with the same color and a similar brushstroke: a down plane, another down plane; a color plane, another color plane. Study how each plane relates to some other plane in the picture. If one plane of the head shows reflected light, consider how another similar plane might show the same reflected light. This is how you follow through.

When you try to understand *what* you're seeing, it begins to make sense. You learn to paint without even trying, and you learn much quicker, too. Understanding relationships is the critical thing.

The diagram analyzes the frontal planes of the face.

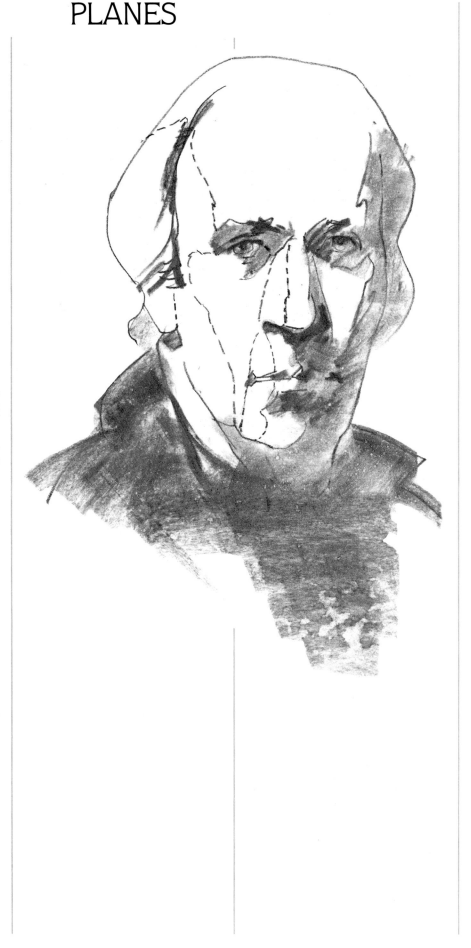

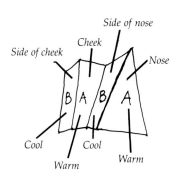

Planes Formed by the Light.
Learn to see in a three-dimensional sense by seeing your subject in terms of flat planes. Seeing in terms of planes helps you see more broadly, without minor intrusive details. It helps you see in a bigger sense.

Picture a female nude facing you. The light is coming from a window, high and to your left. As it falls across her body there is a big plane of light running from the outer edge of the arm on the left and crossing her breast midway to her body. You see all sorts of minor lights and shadows and halftones, but you don't paint them. Just put down one color for this large span of light (the color of her flesh in the light) and paint it without interruptions or details. *Then* paint the "interruptions" (they interrupt the light)— the shadows, the dark gap between arm and body, the area between the breasts—into that light color. But even as you put them in, remember that they're only interruptions, not the main statement. De-emphasize them. Try to keep your eye moving, like the light, across the body.

The large, essential planes you delineate must form a coherent picture of the object. The viewer must be able to look at these planes—without details, just the major flat light and dark shapes—and recognize the object.

If the plane you're looking at seems to have a lot of little lights and darks on it, don't paint it that way. Instead, analyze what you're seeing. Translate it into broader terms. Ask yourself: Am I looking at a light plane with small darker areas on it? Or is it a shadow plane with a few spots of light on it? *Make a decision* as to its overall character. Don't paint a lot of spots as you're seeing it.

Remember that you can't paint only light planes. You must have a shadow plane to give your painting dimension. Arrange your model or the lighting so a part of it falls into shadow.

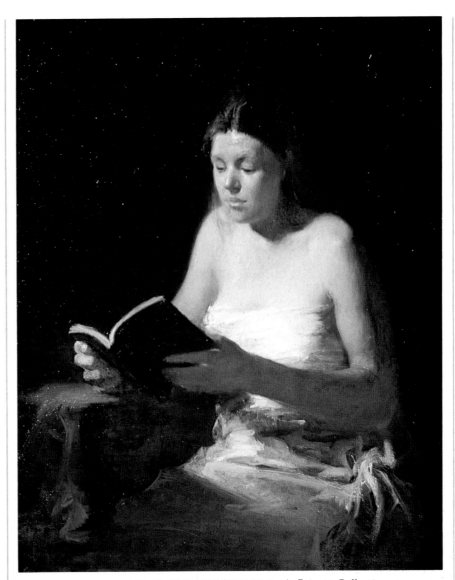

GIRL READING *oil, 28" × 23" (71 × 58.4cm). Private Collection.*

PART THREE
BASIC ADVICE

THE VASE
oil, 16" × 18" (40.6 × 45.7cm).
Collection of the Artist.

LIGHT AND SHADOW

Painting the Lights.
Physiologically the viewer will always look at light areas.

☐ The center of interest is always in the light.

☐ Avoid dabbing your lights on. In painting light on the hair, for example, you must know what you're doing. Try to *create* a light or a pattern related to the form. Take your time and do it. See what happens as you work. You want a direction, a light, a focus. Do everything utilitarianly, functionally. Paint what the light expresses, form or movement.
 Does the light go across the model's hair? If not, can *you* paint it to go across the hair?

☐ Don't lose the original design of your shapes of light and shadow, and value.

☐ Highlights occur at corners or where a plane changes direction. They can indicate the separation of two planes. The temple, for example, is where the side plane of the head changes to the frontal plane of the forehead. Find out where the highlight breaks in this area. A highlight on the lip shows where the lip turns.
 The color of the highlight should be different from the surface it's highlighting. A cool surface takes a warm highlight; a warm surface takes a cool highlight.

☐ On the face and figure in your painting, decide where your light will travel and paint it. *Think* how the light might do certain things and *paint* that picture.

☐ In observing an area of light, the eye prefers the warmer colors (the yellow-orange-red spectrum), not the cooler colors.

☐ Where the shadow meets the light in your portrait, find areas where you can add just touches of color.

☐ A shadow should follow a plane. A shadow along the neck may start at a slant, but then it straightens and runs down, following the form of the neck.

☐ Since light is used to express that which the artist wants to appear to come forward, try to arrange your subject matter so you are facing that part of it that is lighter, rather than facing into the shadow of it.
 All great artists painted their sitters with the light facing the viewer. This is also true of objects that are the center of interest in still-life painting.
 Light is also the foreground material such as the center of interest in the painting.

SYLVIA
oil, 19" × 16" (48.3 × 40.6cm).
Collection of Sylvia Maynard Knox.

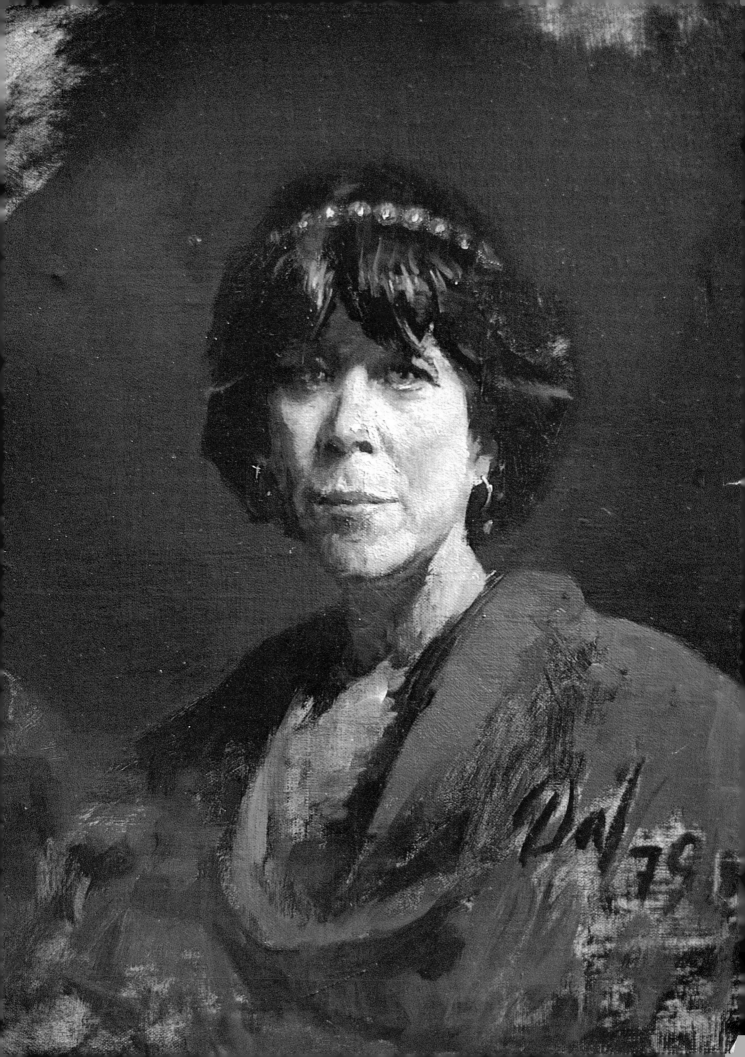

☐ There are only two ways to make something look *lighter*: either make it lighter or make something next to it look darker.

To make something look *darker*, make the light next to it look lighter. Try to avoid adding darker color.

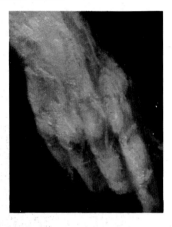

☐ In painting a highlight's tail, try to get it in the direction of where you want the eye to travel.

☐ On the canvas, light should be nearest to the viewer.

☐ Highlights have a crisp edge for brilliance and a tail which melts into the form. Highlights may cover a short or long distance.

☐ Over the years paint gets thinner and loses its body. So right now add more and more light and in the 21st century, your painting will still look light.

☐ You can never paint your lights too light the first time you lay them in. Make them bright. You can always tone down the light if necessary, but it is rarely necessary.

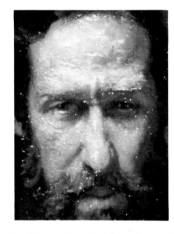

☐ Avoid putting light only in the middle of an object. Light hits the edge, moves across the object, and continues onto another object. You must arrange its path according to your concept, the way you want the viewer's eye to move around the painting. Make your treatment of the light consistent, too. If one area has a high-contrast light, don't paint a nearby area with a weak central light. Keep the quality of the light cohesive.

HARVEY DINNERSTEIN
oil, 30″ × 25″ (76.2 × 63.5cm).
Collection of Daniel Dietrich.

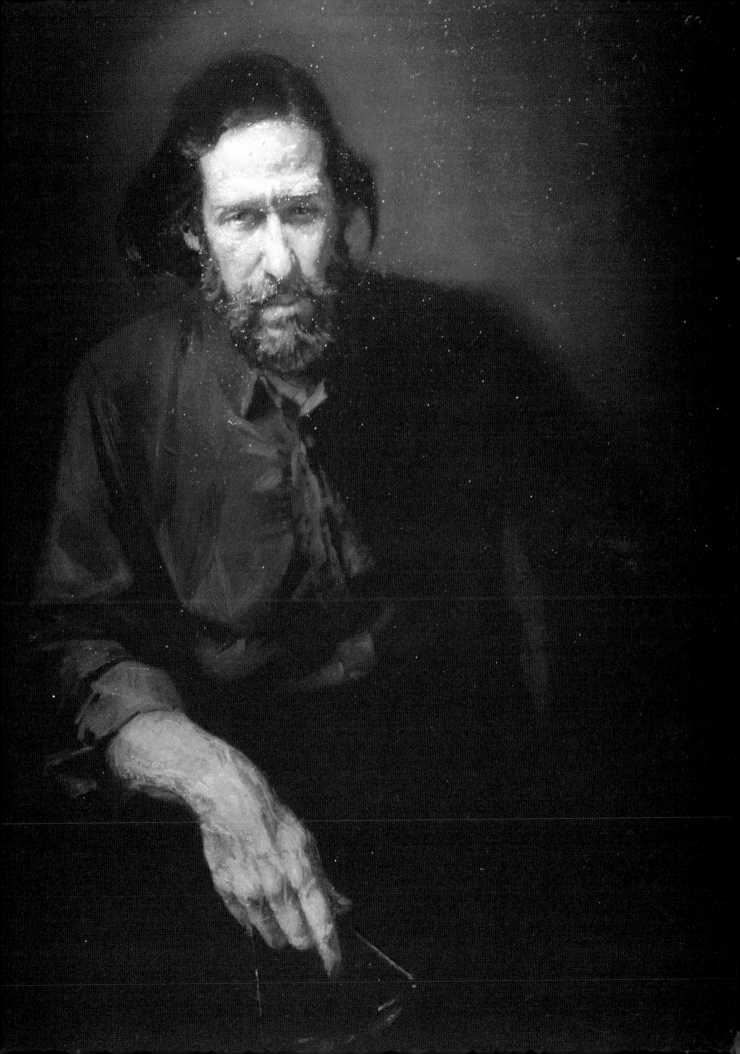

Painting the Shadow. Put enough orange in that purple shadow you're painting to make it shadowy, that is to say, warmer, more transparent.

☐ Accents are dark, descriptive strokes that are as important as highlights. Placing an accent on the tip of a pot handle will help.

☐ Besides structure, shadow provides design and color. Design your shadow shapes.

☐ Work from dark to light in the shadow areas as well as in the light areas. In shadows, work from shadow up to reflected light. In light make lights lighter to make some *look* darker. Avoid adding darker colors.

☐ Cast shadows provide an object with roots and stability and keep it from floating in midair. They are an important structural unit. They help describe the surface the object rests on.

☐ Light is the foreground; all else is background.

☐ Shadow means the absence of light; it is an absolute. Yet shadows are rarely totally dark because light is usually reflected into them from nearby objects. But reflected light does not always result in making shadows light. Sometimes it makes the shadow appear darker by contrast.

☐ In the shadow areas and the background, try to keep the values close together.

☐ Darks get lighter as they go further back. Light is more constant outdoors as well as indoors.

☐ Make a richer statement with your shadows. Use more cadmium colors—yellow, orange, red—with ivory black. Cadmium colors create depth because they make things transparent and the eye equates depth with transparency. Opacity is the look of light. The more cadmium you use, the more space you create. In place of ivory black, you can use umbers or blues.

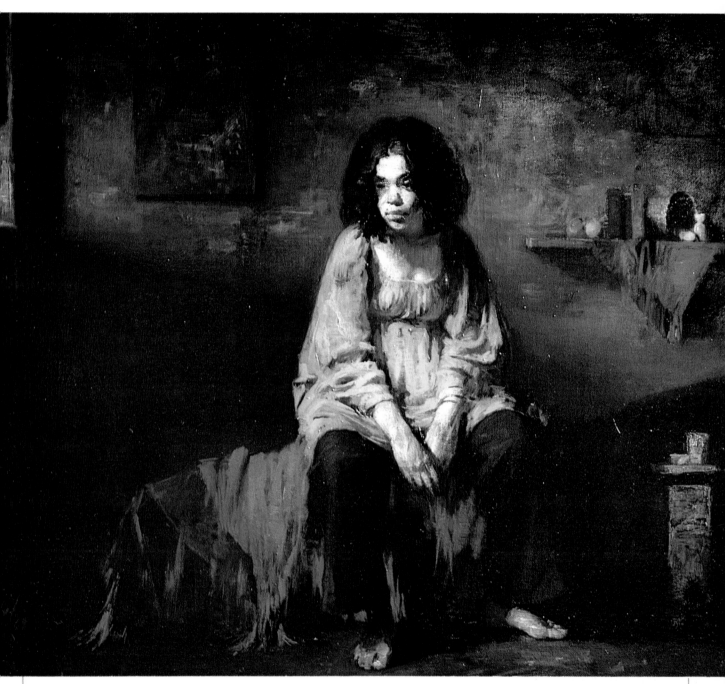

CLAUDIA *oil, 25" × 30" (63.5 × 76.2cm). Collection of Claire Leffel.*

Getting Depth in Shadows.
Keep shadows thin, so that no brushstrokes can be seen in the shadows. Impasto destroys the illusion of shadowiness. If necessary, use more medium to thin the paint.

☐ Some lights look darker than the shadow. This is a result of transmitted light in the shadow—in grapes and eyes, for example.

☐ Avoid making your light and shadow too close in value. The eye should look at the light. The shadow must not, therefore, compete with the light. Make your light strong so the viewer doesn't look at the shadow.

☐ Do the shadow and let it go. Don't try to do any modeling in the shadow. Describing form is not a function of shadow.

☐ You can make a shadow lighter by adding a little white, Naples yellow, or more cadmium color to it.

☐ Make the shadows on your objects more vivid. See how a shadow gives an object dimension, whether it's fruit, a bowl, or an arm. Without the shadow, nothing is going to look solid.

☐ The darkest dark in the shadow is closest to the light.

☐ Build up your light so that the viewer looks at it, not the shadow.
 Paint your shadows in such a way that you don't call attention to them. They should look mysterious, vague, shadowy.

☐ If you have a lot of light, take out some of the color. Don't have both light and color competing for your attention. In other words, in a light area, paint color *or* light.

☐ Think before you put in reflected light. It should be added for a pictorial purpose. Don't just put it in automatically.

☐ Think of shadows in terms of depth and transparency.

☐ In shadows where shapes are contiguous, you don't have hard edges or crispness.

☐ You have to establish the shadow as a different phenomenon from the light. Light is cool and refracts off a surface. Opacity is the look of light. Shadow is more transparent. Add warmer colors to your shadows. Think of shadows in terms of depth and transparency.

☐ Light is the melody. It moves, it rises and falls in intensity.

☐ Don't worry about the color of the shadow matching the color of the light. They do not *have* to match. A blue smock does not necessarily have dark blue shadows.

COFFEE BREAK
*oil, 18" × 24" (46 × 61cm).
Private Collection.*

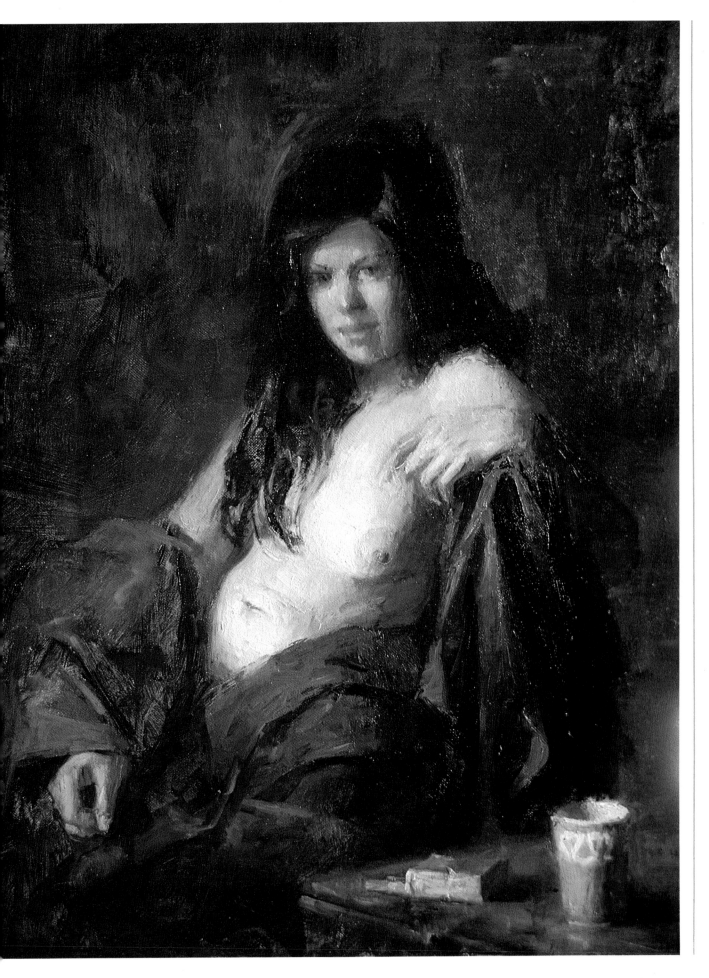

VALUES

A finished painting should have essentially the same values you assigned to it at the beginning. All things within the same picture plane or distance should have the same or similar value. If you follow this rule, objects stay in their rightful place in the picture and do not jump out at you, or recede too much.

At the same time, the picture has to look three-dimensional and show depth. You can accomplish this without changing values through changes in temperature, edges, or intensity. How do you do this?

Change in temperature: Use warm and cool colors of the same value.

Change in edges: Use hard and soft edges. Soft edges give a duller look; hard edges are more vivid or brilliant.

Change in intensity: Use a more intense color of the same value as another duller color.

☐ Always try to conserve your values. That is, use as few different values as possible. You can put in subtle value differences later. The range of values is usually the first thing a student uses up. Make warm or cool color changes rather than value changes.

☐ Arrange your shapes with some geometry—all the darks and lights necessary for painting into that shape, the shape of the light, shape of the dark, and so on.

☐ Value is the lightness or darkness of the shapes and elements of a painting. The specific value is arbitrary. What looks like one value to one person can appear to be another value to someone else. Each person is right, as long as the values relate to each other.

☐ Adjust your values to control perspective, depth and design.

☐ Paint *everything* from dark to light, the darks or shadows as well as the lights.

☐ Decide on your values for the finished painting early. Color is easy, value is difficult.

☐ Arrange your values immediately for the finished painting. Decide how light or dark the shapes will be. Color is easy to understand; value is more difficult to grasp and see.

☐ When something goes back into space, its value should be similar to other values in the same plane so that it won't stand out. There should be a close relationship. When something comes forward, there should be less of a relationship with its background and more of a contrast of values. For example, if a person's complexion is the same color as the background, it won't appear to come forward.

If you can keep your value relationships in mind while you're working, painting will be simpler.

☐ When painting fabric or material, keep the shadow value consistent for each piece of fabric or material throughout the painting. Darker material has darker shadow, lighter material has a lighter shadow.

RED KIMONO
*oil, 23" × 20" (58.4 × 50.8cm).
Courtesy of O'Brien's Art Emporium,
Scottsdale, Arizona.*

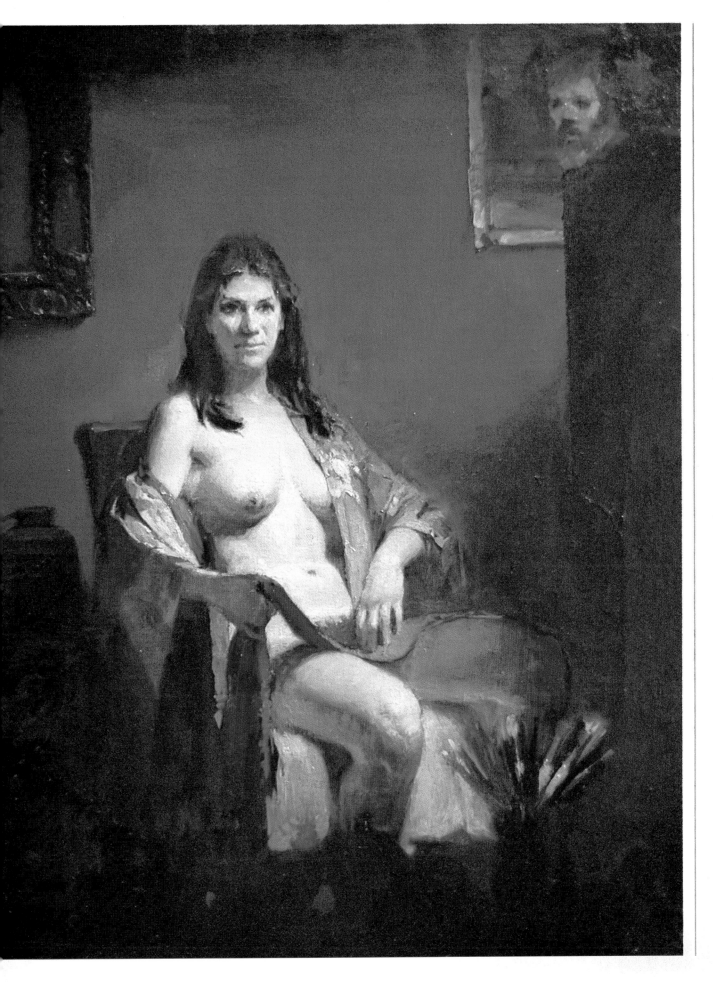

EDGES

Edges help the painter convey the illusion of three-dimensional form on a flat canvas.

All objects in your painting have inside edges and outside edges. The inside edge of an object is where the plane or form changes direction. The outside edge is where a form begins and/or ends; it faces the source of light.

If you're dealing with the human form, the outside edge can be part of the same surface anatomy. For example a vein that is raised from the surface of the arm has an outside edge where it hits a new plane on the arm, and an inside edge on the vein itself where the light and shadow come together.

There are two other kinds of edges—hard and soft. A hard edge is clear and distinct; a soft edge is fuzzy.

An important lesson to learn in trying to portray a three-dimensional form is that the eye will automatically focus on the cleanest, sharpest thing it sees. In addition, when the eye focuses on a hard, thin edge, it tells the viewer that the object it sees is not round or dimensional; that it is very thin because only very thin things—like leaves or a sheet of writing paper—have such sharp edges.

When a painter paints a hard edge where an object meets a background, that edge will be a strong place of focus. It follows, then, that if the focal point is away from the edge, that is, inside the material, the mind's eye is not conscious of edges, and the illusion conveyed is that of form or mass. Therefore you have to get rid of the edge as a place of focus and give the eye a new focal point off the edge. How do you accomplish this? You can eliminate the outside edge by dragging two wet layers of paint (the light and the shadow) together, blending their edges.

The far edge of an object also can be removed as a place of focus by lightening the background where the edge and background meet.

☐ Edges on the lighted side do not start darker. When light hits a surface, it is as lit up at the edges as it is inside.

☐ Edges are wonderful. You can paint a flat plane, then by just varying your edges, you can achieve a dimensional quality.

☐ A soft edge shows continuity. The softer the edge, the duller the look. A hard edge shows ending. The harder the edge, the more riveting your painting is in that area.

CARNATIONS IN PEWTER
oil, 12" × 14" (30.5 × 35.5cm).
Private Collection.

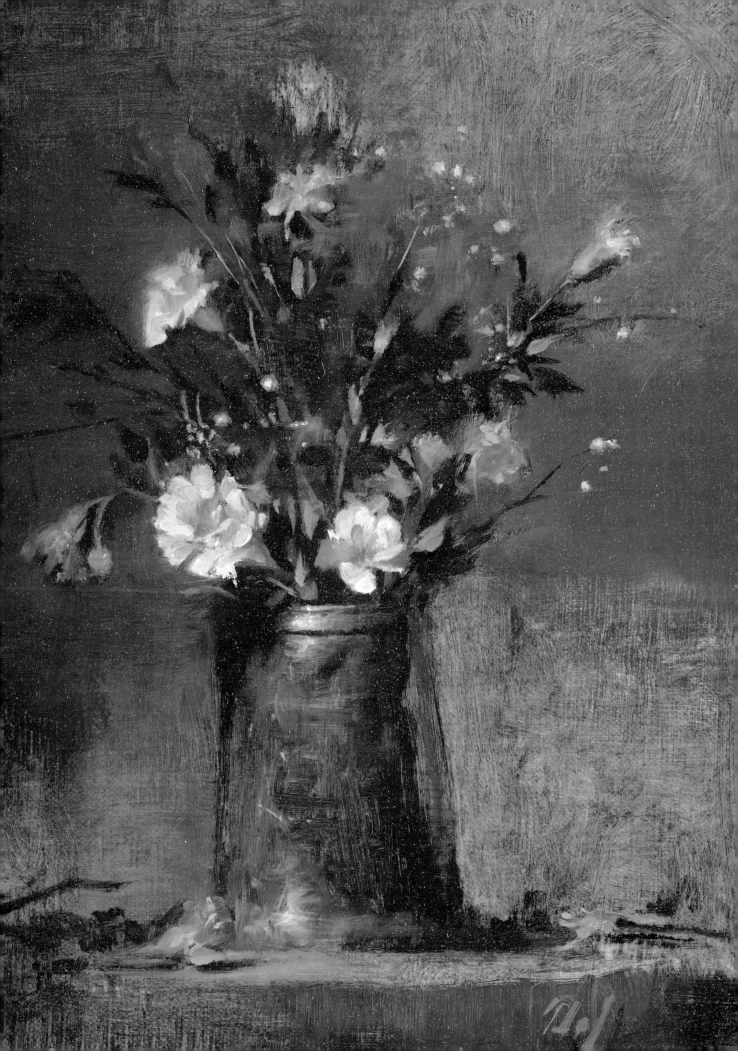

COLOR

☐ Get all your colors on the canvas quickly. Get them in front of your eyes so you can see how they relate. Determine your background color immediately, then the colors of the various elements in your painting. You can then integrate everything for an overall look.

☐ White is the coolest color. Adding white to another color will make that color cooler. White also adds opacity.

☐ To make something look bright or brighter, use more color and less white.

☐ To make yellows, oranges, and reds lighter, add white or Naples yellow.

☐ Some teachers tell students not to use black because it's a "noncolor." What if Velasquez had believed this?

☐ Mass in the shadows on all your objects first. Then apply local color as, for example, the orange and yellow on oranges. For the transition color between the shadow and the local color, you can pick up the color of the air background.

☐ Try to use your paint and colors in a painterly fashion. Make your pieces of color *look* like nice pieces of color.

☐ The color of light falling on all the different colors will unify them.

☐ The first piece of color and/or value you put down should make a definite statement. Otherwise, you will not be sure how the second statement relates. After the first piece of paint, or statement, is on the canvas, you can determine whether or not the second should be lighter or darker or have more or less color.

☐ Use color to make something happen, for example, to bring things forward. A bit of warm color in a grayed area will suffuse that area with warmth.

☐ Warm color has a transparent nature and has the look of real depth or shadow.

☐ Yellow is the color of transmitted light. It will make almost anything look transparent, especially shadows. Orange and red also bring about these results, but yellow more so. When you're painting leaves, or paper, if you put enough yellow in the shadows, it will make them look transparent.

☐ Reserve your most intense color for the areas in the light.

RICE BASKET WITH SCREEN
*oil, 25" × 22" (63.5 × 55.9cm).
Collection of Mr. and
Mrs. Milton Meyer.*

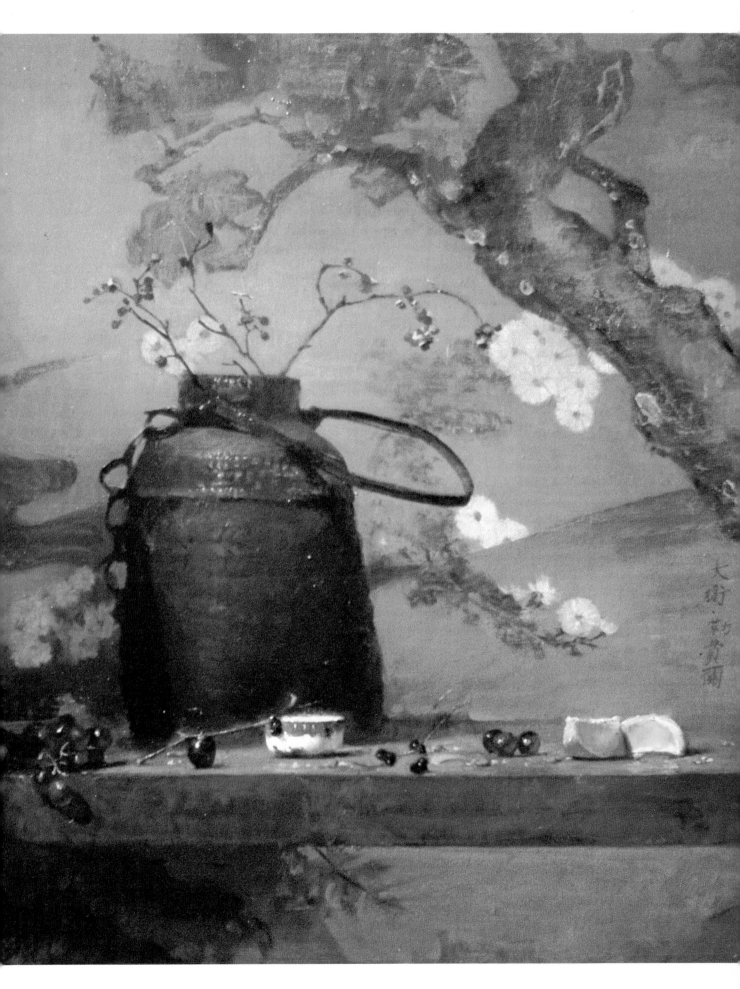

Mixing Colors. Place your color on the canvas and leave it alone. If you spread it and play with it, it will become muddy or chalky. Chalkiness is caused by having too much free-floating color in an area, not by using too much white as many students believe. The color has no boundaries and the eye of the viewer is often unable to identify the area as even having a color.

In other words, color, in order to be identified as color, must occupy a finite area. That is, you must be able to distinguish your colors on a form or even in a background. Don't mush your colors together. If you do, the areas will look chalky or muddy. Muddiness is chalkiness in a lower value. Crispness is also color. Muddy or chalky color is often due to a lack of crispness.

☐ More is always less. If you see seven colors that are all equally important, each one is worth only 1/7th. Create a focal point in your paintings by using one strong color against pieces of colorlessness.

☐ Transition colors should not be noticeable. They should be transitory, ephemeral. Use various shades of "murk" (neutral color).

☐ To change the value of black, change the temperature. Adding a warm color to black will make it look darker; adding a cool color will make it look lighter, at the same value. (To make black look lighter, never add white; that will only make it look grayer. Instead, add a bit of cobalt blue or raw umber.) You can cool your black by putting cobalt blue into it. If you want to make the black richer, add a cadmium color. Cadmium colors are clear and transparent. If you use an earth color, say yellow ochre, you would get a more opaque look.

☐ Warm colors advance and cool colors recede. The human eye expresses a natural preference for yellow, red, orange; it sees gray, blue, green only peripherally.

☐ When mixing colors on your palette, don't mash the colors into each other. Try to paint the colors together with the same consideration you use to paint a delicate nuance on your canvas.

☐ Make a distinction in your mind between painting light and painting color. Each requires a separate brushstroke. You cannot paint light and color at the same time. The more light you have on a surface, the less color that surface will have.

☐ A combination of black, cadmium yellow, and white makes a good shadow color for white objects.

☐ *Critiquing a student's work*: That red won't come forward; it will recede because it has a lot of blue in it. Use cadmium red light which is balanced toward orange to have it come forward. Venetian red, as well as cadmium red, will bring an object forward.

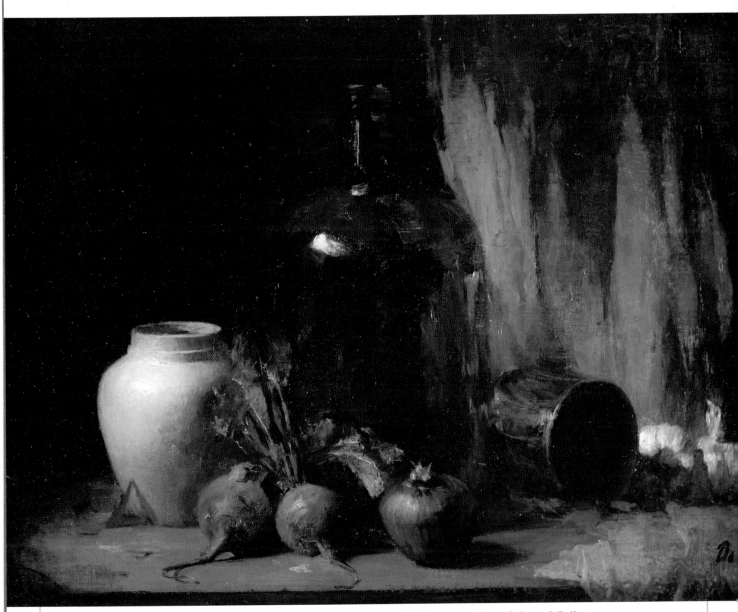

TEXTURE AND LIGHT *oil, 16″ × 22″ (40.6 × 55.9cm). Courtesy of Grand Central Galleries.*

The Same Subject, Two Different Background Colors. I loved this vase so I painted it in two different color settings: one orange and umber and the other greenish blue (opposite). I wanted to explore how these background colors would affect the color of the vase. Both the warm orange colors and the cool blue-greens emphasized different colors in the vase and different textural effects in the background.

This ancient Persian vase was loaned to me by a friend, as was the Afghanistan carpet. The vase with the dried peonies was painted as the central point. Light and texture were used to make the vase the most dominating object. The basic color is green, surrounded by a lesser cast of red and black purples.

☐ Make your colors as light and bright as you can the first day. You can't work too light when you first apply your bright colors. Once that first day's paint dries, it gets much darker. But when a color dries, you can make it more brilliant by reapplying the same light colors of the first day. They will look much brighter and remain bright.

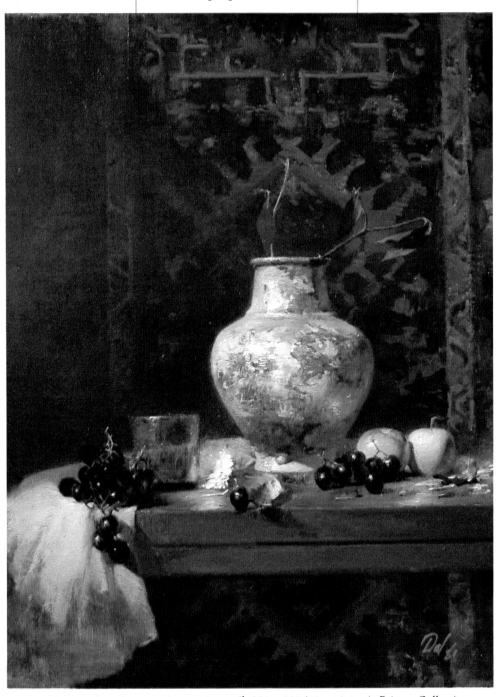

PERSIAN VASE WITH APPLES AND RUG *oil, 28″ × 23″ (71 × 58.4cm). Private Collection.*

☐ We impute color to things according to our conditioning. As children we learn grass is green, plums are purple. We should test our eyes and minds more and learn to see things as they actually are.

☐ You can either put color in one place or de-emphasize color in another place. Remember, it's color against colorlessness.

☐ For local color, which is the color of the object itself, use the richest colors you can find. Generally, think in terms of more, brighter color for your areas in the light.

☐ Try to decide on the colors of your painting before you make your first brushstroke.

☐ If your background is too warm, try a touch of Naples yellow to give it an opaque airy look or to make it go back so that the figure comes forward.

PERSIAN VASE WITH ORANGE AND SCREEN *oil, 28" × 23" (71 × 58.4cm).*
Collection of Mr. and Mrs. William Spencer.

PAINTING STILL LIFES

Getting Good Shapes.

☐ Keep the shapes of your objects. Hold on to them. If they're part of the background, don't let them disappear into it. All shapes should be distinct to give your picture a sense of design and structure.

☐ Everything has a shape. Each shape must retain its integrity throughout the painting.

☐ Arrange your shapes with some geometry—all the darks and lights necessary for painting into that shape, the shape of the light, the shape of the dark, and so on.

☐ When you are painting a series of objects, put in your center of interest first! This is very important. Size and place your center of interest first, then work back from there.

ARRANGEMENT IN GREEN AND WHITE *oil, 12" × 17" (30.5 × 43cm). Collection of David Kramer Estate.*

Painting Grapes.

☐ Color a still life as a composition. Bring unity to your use of color. For example, when painting a grape, think of creating a highlight with a bit of light yellow from a nearby lemon.

☐ If you add more light to the ground in front of the grapes, they will look lit up. Objects will not look lighted unless the surface they're on *looks lighted.*

☐ For green grapes, try Prussian blue and cadmium yellow.

☐ To make a grape fade into space, make the edges less clear; put some background color on the edges.

☐ I once had a still life in a gallery that didn't sell. It was a vase with blue grapes falling over a table edge. I realized it had a gray, monotonous look. After removing it from the gallery I added yellow grapes, which gave it a richer, more colorful aspect. It sold almost immediately.

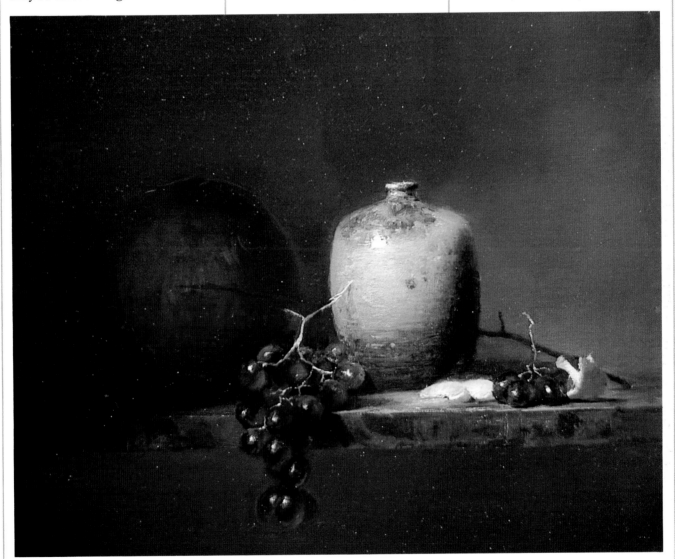

CRESCENDO OF ORANGE *oil, 14" × 16" (35.5 × 40.6cm). Collection of the Artist.*

Handling Color.

☐ If the overall effect of your still life seems monochromatic, introduce a second color, an opposite color. For example, a still life that has too much yellow-green might be helped with the addition of blue-purple.

☐ The red and green in these apples must have something in common to make them appear to be on the same surface. For example, make it a *blue* green with a *blue* red or a *yellow* green with a *yellow* red. There must be a common factor to unify the colors to make them look like they belong on the same object. It depends on the color of the light falling on all the objects.

☐ If your still life appears gray and lacking in pictorial interest, it may be that the elements in the background run into one another without differentiation. A background fruit may be too shadowy and melt into the surroundings. Emphasize the fruit more and give it more fruit color.

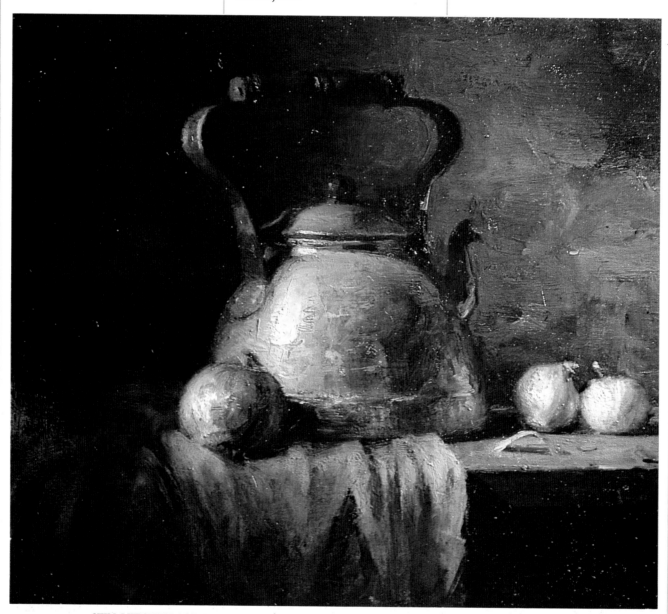

STILL LIFE WITH COPPER TEAPOT *oil, 12" × 14" (30.5 × 35.5cm). Collection of William Hoelzer.*

☐ Add alizarin to the shadow of a plum to make it appear more transparent. Adding alizarin (or cobalt yellow or sap green) to any color will make that color more transparent.

☐ Make sure the shape of your fruit is distinct. Don't paint your fruit spottily. What you're seeing are the secondary characteristics—odd bumps, flecks of color—of an apple. (Primary characteristics are shape and color.) Painting is seeing the structure of things, the design, the nature of what you're painting, and how that relates to the picture.

☐ If the fruit is the only really colorful thing in your picture, it can still work. It's the *design* that does the trick.

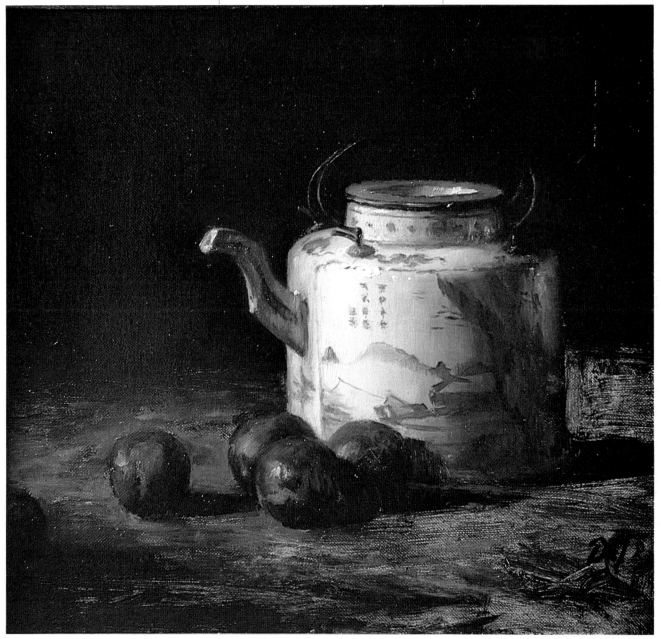

CEREMONIAL TEA URN *oil, 16" × 18" (40.6 × 45.7cm). Private Collection.*

Thinking in Paint.

☐ Decide what you want to do and approach it by thinking you're going to *describe* it on the canvas. Find something within that onion that you can make a description about. It doesn't matter how you do it. Just pick up a piece of paint and *describe* the shadow and the cast shadow of the onion. Do the shadow and the cast shadow on your onion all at once.

After you apply the piece of paint to the canvas, let it go. Don't smudge the paint around. If you go over a piece of description, go over it the same way you applied the first piece.

☐ In painting a still life, the principles are the same as in painting a portrait or landscape. Only the subject matter changes. In all cases, you paint values, color, focal points, and edges.

The description is finite; it can't cover a large area. Each piece of paint should be one description, a gouge in a table top, for example. Then you can apply the light on it with another brushstroke, if necessary. You can go only so far with each description if you want to describe it accurately.

Remember to have enough paint on the brush to make the description *and* to apply any light reflecting into the area.

☐ Should you paint red onions, use alizarin and black. Smudge in your color first, using lighter and then heavier brushstrokes to get different effects with the colors. This will give you an interesting base to work on.

☐ Do the shadow and the cast shadow on your onion all at once.

☐ Paint the *principle of how things function*, or how they're known. Don't paint by copying. Don't paint things; paint light on things. It's essential to *translate* what you see, not to copy. In painting an orange, for example, find the essential qualities of an orange, what makes it what it is, and paint *that*.

☐ Paint in enough finished things as soon as you can get to them. This is encouraging and it will keep you going.

☐ Do the basic design and shapes at the beginning. When the painting is finished, it should still have your basic design and shapes. This is important.

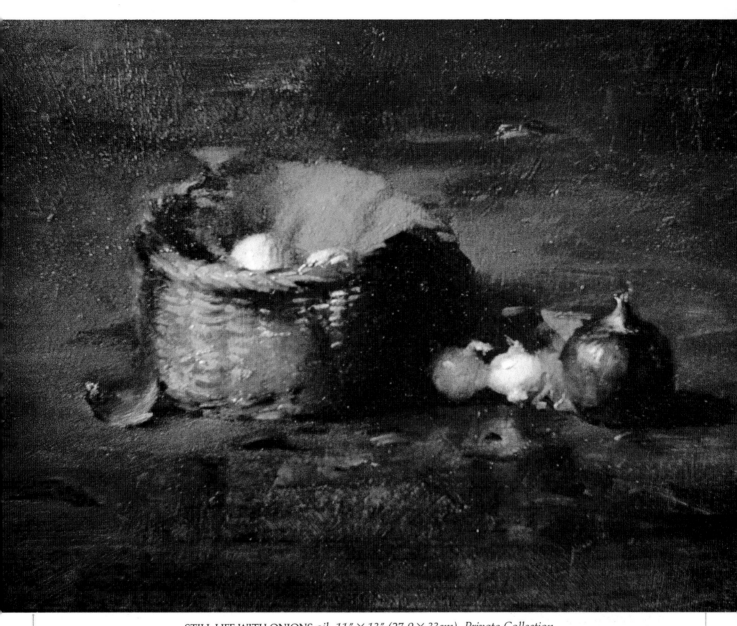

STILL LIFE WITH ONIONS *oil, 11″ × 13″ (27.9 × 33cm). Private Collection.*

Working It Out.

☐ On any warm surface, such as the warm wood of a table, you get some cooler light. Cool light on warm wood—it's how you see it. Separate what you see into how you can paint. And go with that.

Fill in some cool light (cobalt blue and burnt umber) on the table area where the pot handle is. Fill in cobalt and black for a lighter cool around the onions. Cobalt blue, a more opaque color, gives the feeling of light falling on a surface. See *Maroger Pan and Bottle* demonstration, pages 50–51.)

☐ The best way to paint objects is by section or entity, rather than by outlining the entire piece. With a bottle, for example, shape the bottom part as one entity, the neck as another, and so on. Paint the component parts to form a whole instead of drawing a line around the whole bottle.

☐ When an object, say a jar, has a design, the design wraps around it and conveys form. Consequently, you don't have to paint too much form into it.

☐ Whatever you did the first day, do it better the second day. If the grapes you did the first day are not dark enough, you can make them darker the second day. The paint is too wet to do this on the first day.

☐ You're not a mechanical camera: Select from the myriad facts about the objects and shapes out there the ones that fit your particular context.

☐ In a still life, the ground plane is the most important plane. Establish it as soon as you can. Then work up from there.

☐ Make the shadows on your objects more distinct. See how a shadow gives any object dimension. Without a shadow, nothing is going to look solid.

☐ The orange is a solid object, put a line of shadow underneath it.

BITTERSWEET WITH PERSIAN VASE
*oil, 28" × 23" (71 × 58.4cm).
Private Collection.*

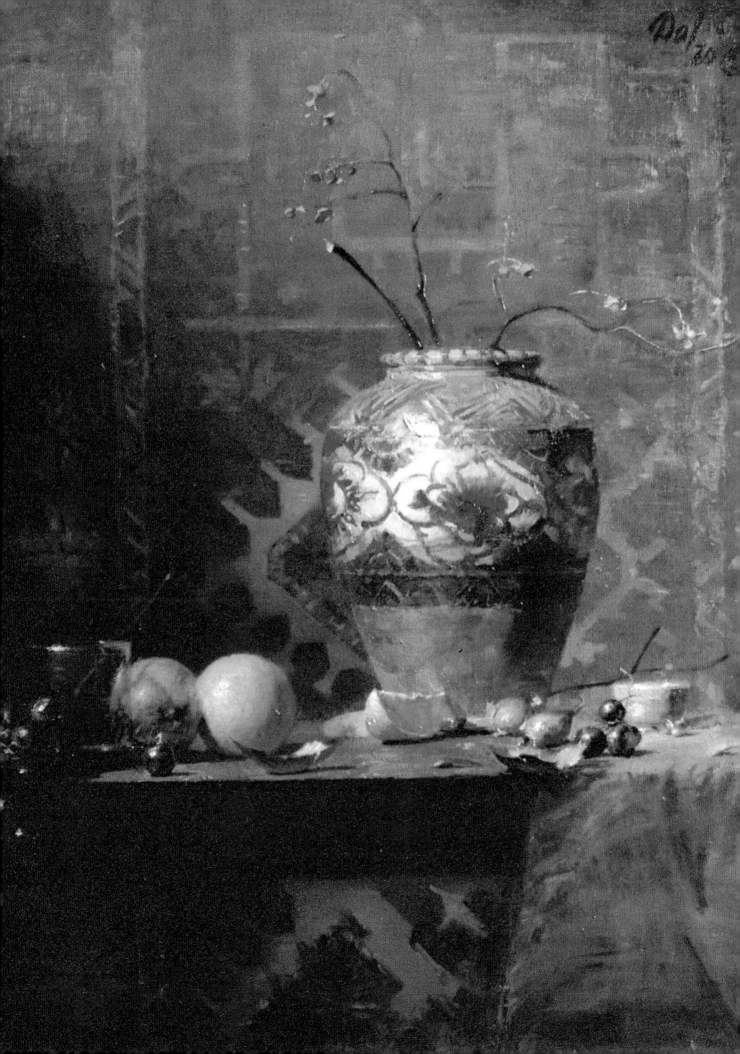

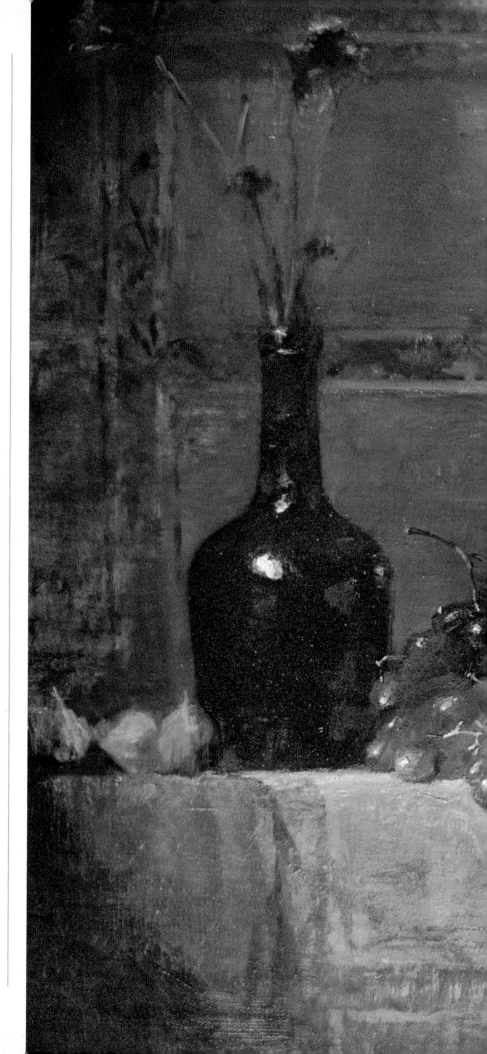

One Last Look.

☐ The shapes in this still life hold together beautifully. The group of oranges makes one unit, the grapes hold together, and the vase does too.

☐ If a white tablecloth is painted stark white, it may look unrelated to the rest of the picture. To soften it, introduce brushstrokes of color from the light section of the picture. This will also help unify the painting.

☐ Spend time at the beginning of your painting getting the placement of your objects right in terms of mass and shape. Draw shapes and sculpt. Cut into it, thinking sculpturally. Be loose. You'll make the shape more specific later.

☐ When you place a highlight on a bottle, for example, place it and let it trail off. Don't play around with it. I often use a dark bottle with a long neck and squat body and put three highlights on it: one at the top rim where it turns into the neck, another at the bottom of the neck where it turns into the body, and the third where the body of the bottle turns at the side.

 Highlights on a bottle are crisp because glass refracts more light. Highlights on a peach, on the other hand, are diffused and fuzzier because the surface is softer.

 If you're painting an object that looks somewhat shapeless, add a highlight and it will look better.

☐ Avoid putting all your light in the middle of an object with nothing going to the edge. Light should start at an edge; it should continue. *You* may have to decide how it is to continue. If you have one fruit with a bit of framed light and another fruit with a bit of light they will lack cohesion.

STILL LIFE WITH PRAYER RUG
*oil, 20" × 24" (51 × 61cm).
Collection of Mr. and
Mrs. Peter Stremmel.*

PAINTING PORTRAITS

When you paint a portrait, the right bone structure or topography will give you a likeness. Think topographically; this area goes in, this area comes out. And if you get the depth of the ins and outs right, it will look like the person even before you put in the pupils, nostrils, or mouth.

In other words, the bone structure will give you a general resemblance. At 25 feet it is the bone structure that supplies the resemblance because at that distance, you can't see all the details of the face.

Don't think of the features specifically as the mouth, nose, or eyes, but see them as part of the topography moving in and out of the depth of the picture. For example, for deep set eyes, use deeper values; for a prominent nose, use a deep shadow value. When you're painting someone, you're evaluating the topography. Use values and colors that emulate the topography.

Don't work consciously to get a resemblance by copying individual features and trying to make them look exactly like the model's. Look at the person as a whole and try to understand what you're seeing. You'll get a resemblance almost automatically, without even trying.

☐ Where the shadow meets the light in your portrait, find areas where you can add touches of color.

☐ In the light part of the face, when you want to get more of a spotlight on the upper half, try lowering your values on the bottom half.

☐ The muzzle (the area between the nose and the mouth) is basically the same color as the skin but cooler than the cheeks. Add a little red in the philtrum (the depression beneath the nose).

There is a highlight at the side of the muzzle near the canine tooth.

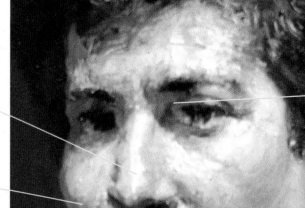

Use light values for protruding areas.

Add more color where the shadow turns into the light.

Add a little red to this shadow.

Use dark shadow values for deepest areas.

There's a small highlight here.

Lower values gradually as face turns under chin.

FRANK JANCA
oil, 16″ × 14″ (40.6 × 35.5cm).
Courtesy of Grand Central
Galleries, New York, New York.

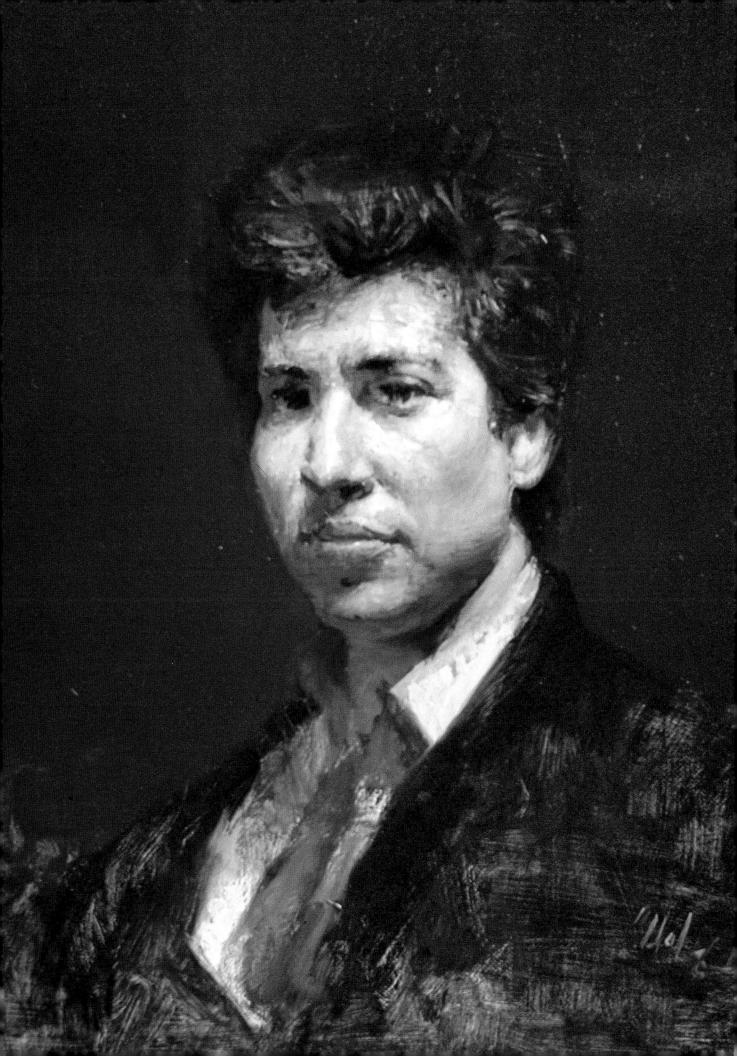

Shapes and Planes.

☐ The neck and throat are usually not too important in a portrait. Unless they are emphasized for a specific reason, leave them alone. Make your necks recede by adding some cool color. Remember to simplify your objects.

Because the neck is further back than the head, it is painted in relationship to the background.

☐ Here is a way to approach the painting of a face. First, see the face in terms of planes and colors. For example, the front of the forehead is one plane, the side (where the forehead turns at the temple) is another plane. Then decide on your warm and cool complexion tones. After you've applied your shadows, paint your complexion tones in regard to the planes you've assigned them: X planes, warm; Y planes, cool. Do this crisply. Then you can go back and do some modeling, or soften the edge between the planes for subtlety. (See also "Planes," page 56.)

☐ A shadow should follow the form. A shadow along the neck may start at a slant, but then it straightens and runs down, following the form of the neck.

☐ The diamond shape represents a recognizable generality for the coloration of warm tones on the face:

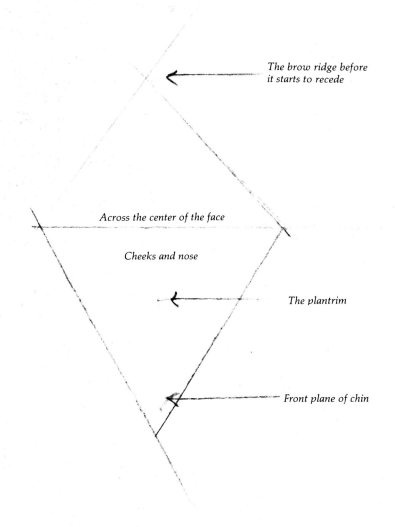

The brow ridge before it starts to recede

Across the center of the face

Cheeks and nose

The plantrim

Front plane of chin

THE FIREMAN
oil, 16" × 14" (40.6 × 35.5cm).
Collection of Gregg Kreutz.

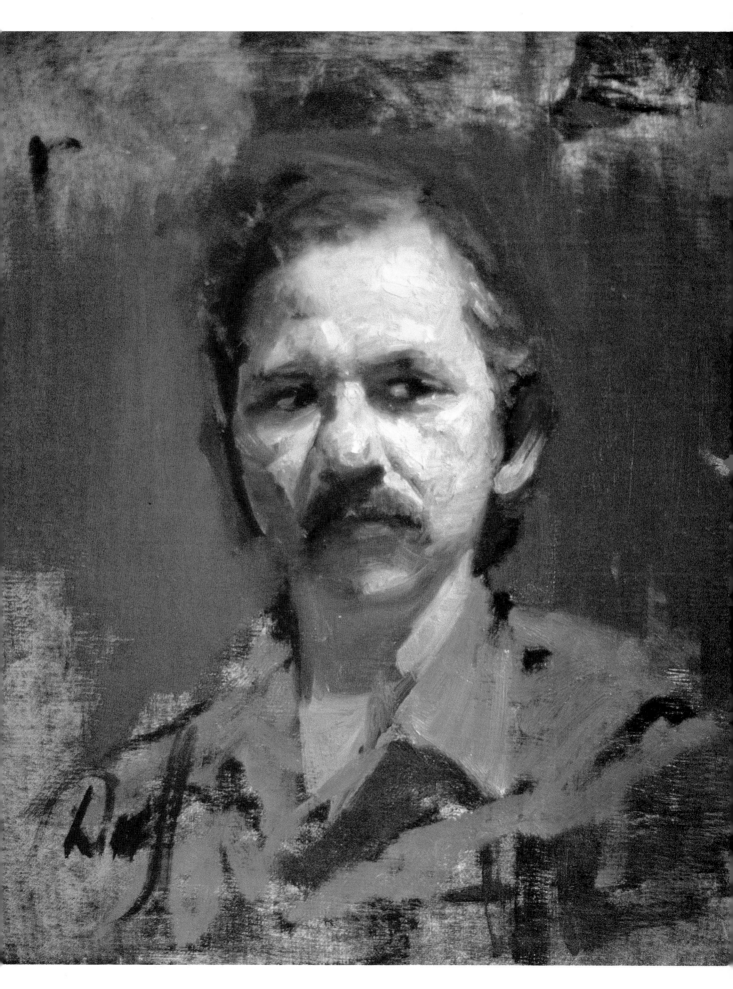

The Complexion.

☐ When it comes to complexion, you will find it's more effective to use earth colors for a swarthy skin and cadmium colors for a finer, fairer complexion.

☐ In the light area of the face, you need both a warm and a cool color to make the skin look right.

☐ The lower part of the face in the light area is cool and gray. Adding background color to the flesh color in this area will make it recede.

☐ Make the background color similar to the shadow in the face, so that the light area will be completely different.

☐ The light has to end on a structure. If you're painting light on a bone structure, for example, the light should end where the bone ends or turns.

☐ When you're doing a three-quarter face, remember that the angles of the nose and mouth on the near side are more extended. On the far side they're steeper, more collapsed.

☐ The hair has to have integrity, that is, a visible form. It can't just melt into the background. Make the hair a distinct shape.

Later, when you put in your strong focal point—the high-lights—on the hair, the viewer won't notice the peripheral areas, the edges of the hair shape.

☐ The shoulder of the near side of a portrait is most important. It is part of the structure. Get it in along with the whole gesture of the body. And get it crisp.

ALMOST EVEN

LONG SHORT

JANE ROSENBERG
oil, 24" × 20" (61 × 51cm).
Collection of the Artist.

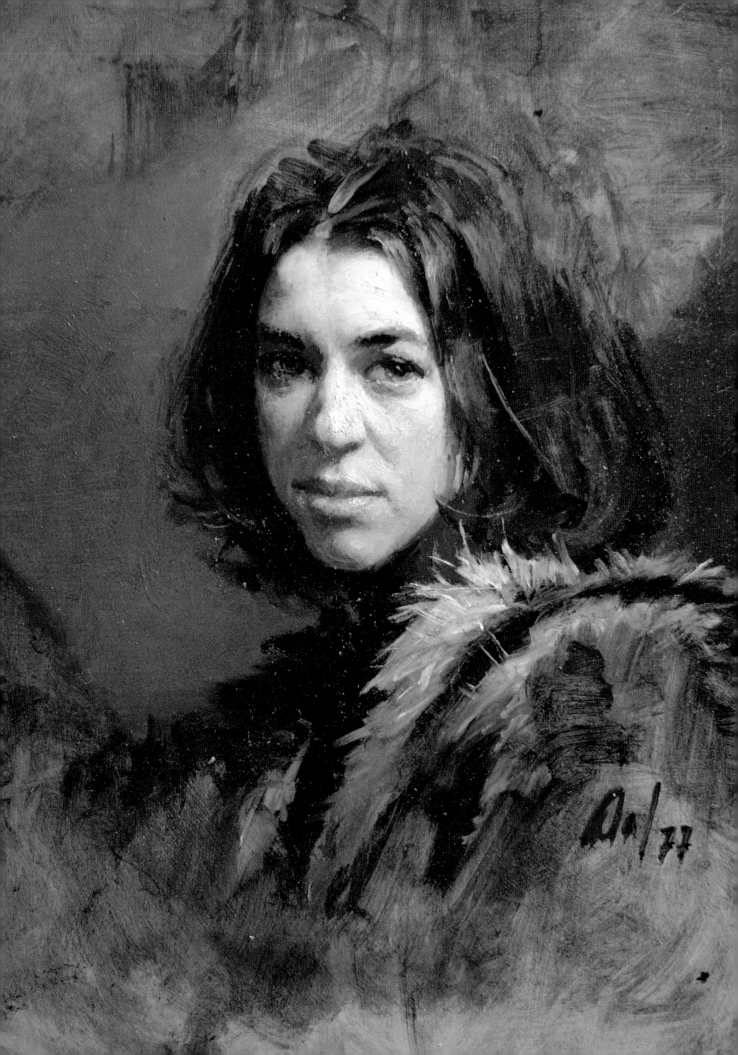

More on Complexions.

☐ Make an assessment of your model's complexion. Translate it into a pigment on your palette. Don't blend the paints; mix them lightly. Use gray for receding areas. Your first brushstrokes in the light part of the face should be very bright, light, and colorful. Make your first application of paint as bright as you can because it will dry to a greatly reduced intensity.

☐ The muzzle (the area between the nose and mouth) should start to lose color. Put in some raw umber as a cool color and repeat the raw umber on the side plane of the face.

☐ As you're doing the face, use the same amount of paint for both cool color and warm color.

☐ Watch your painting as much as you watch your model or still life. You must see what is happening on your canvas. Your painting is what's real.

☐ Do hair as a dark shape and as part of your design. Don't do any fuzzy strands or squiggly things yet, just do a simple shape.

☐ Compose your colors, using the model as a catalyst. The colors *you* put in are what's important, not what you see. You must appraise the warm and cool colors of your model's complexion and then translate what you see to pigments on your palette. Use these colors as your vocabulary to express the planes and topography of the sitter.

☐ If the face in your portrait lacks solidity and the light seems to come through the shadow area, drop the value of your shadow to block that light. Shadow has to look dense enough to appear solid, yet transparent enough to recede.

☐ When you see something receding or when you view something at an oblique angle—the temple, sides of the face and nose, chin area—think of cool color. Again, use color as a vocabulary. By that I mean assign a color to a plane, that way you'll use the same color to express specific planes in your paintings. This will give your work a unified look.

Receding areas go through space and back into space. This means you must use cool color. The cool colors are grayed blues, greens, purples, and grays.

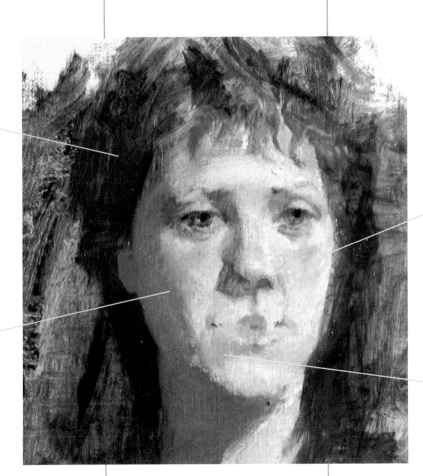

Paint hair as a simple shape.

Make the first brushstrokes on the face colorful.

Shadows should be solid, yet recede.

Flesh loses color as it turns under forms.

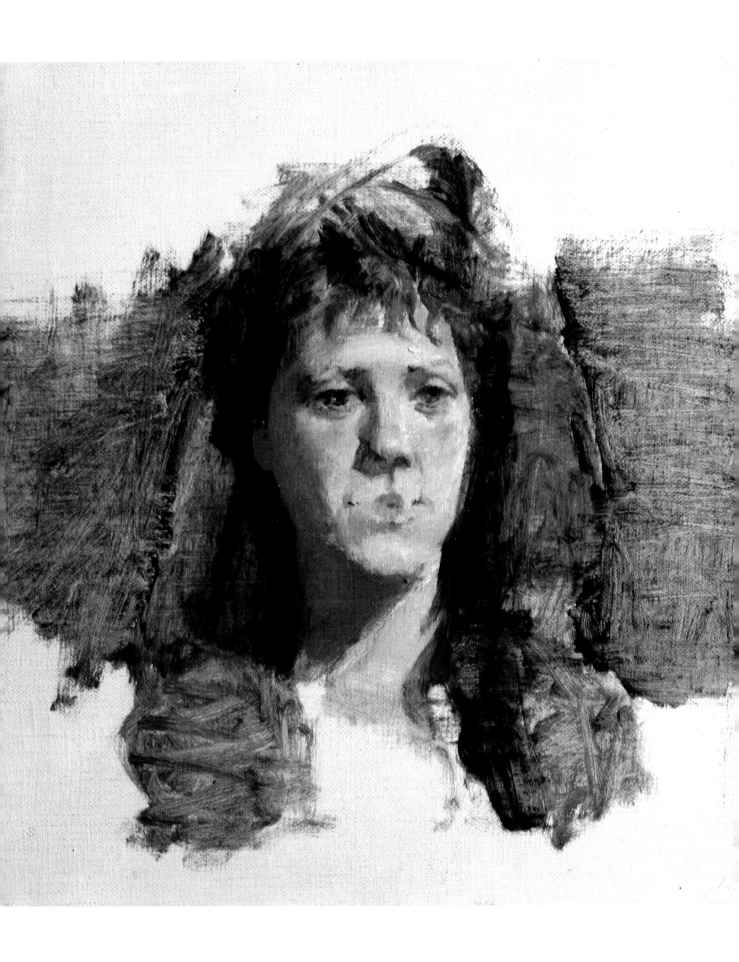

Closeup on Color.

□ Try to avoid making your complexions too muddy. Use bright pigment for complexions. Try white and Venetian red, for example. Mix the two on your palette as though you were painting them together; with care, not like making pancake batter. Don't mix them thoroughly. Set this warm mixture aside in one pile. Then put a cool color beside it in another pile. Now apply your colors in terms of the planes indicated in the diagram. Apply on one side, then apply the same colors on the other side, and keep the values until later.

There is one constant and one variable; where each comes depends on its place on the face: On the cheek and nose area the color is preponderantly warm indicating fleshier substance. The cool color then modifies or indicates plane or form change. On the lower part of the face, including the chin area, there is an abundance of cool color indicating a bonier substance, with some warm color modifying it.

□ In the light, the colors Venetian red and yellow ochre are good for the more sanguine area of the face (the cheeks and nose area).

□ Gray the lower part of the face because here, you're describing more side plane, more jaw. Follow the form. The mouth area has many small planes in transition and transitional planes are painted cooler.

□ Use the same colors and values again and again to unify your paintings. For example, you can use the same shadow color for the hair that you use for the face, but darker. (I suggest you paint all the hair with the shadow color and then add your lights later.)

The accents in the hair and eyes should be the same value. The darkest darks in the hair should be the same value as the pupils of the eyes.

Avoid using a variety of values in your shadows too. Use the shadow value of the eyes for the nostrils, for example. In other words, repeat the same value as often as you can.

Keep the value of the pouch under the eye somewhat close to the value of the skin. Otherwise, they won't appear to belong together.

□ You can't have two separate colors or chroma—red and yellow—for the complexion. Use warm against cool, not two colors. The skin has to be red, *or* orange, *or* yellow ochre, plus cool—not two colors. This cool, or second color, has to be colorless. If it's too strong, say a blue, float skin color into it.

Skin color is a special thing. It has no local color. It's elusive; it doesn't hold still. You'll find skin warm in one place and cool in another.

□ When you complete the eye, you'll notice that other parts of the face will look somewhat finished as well. It's an encouraging stage in a painting.

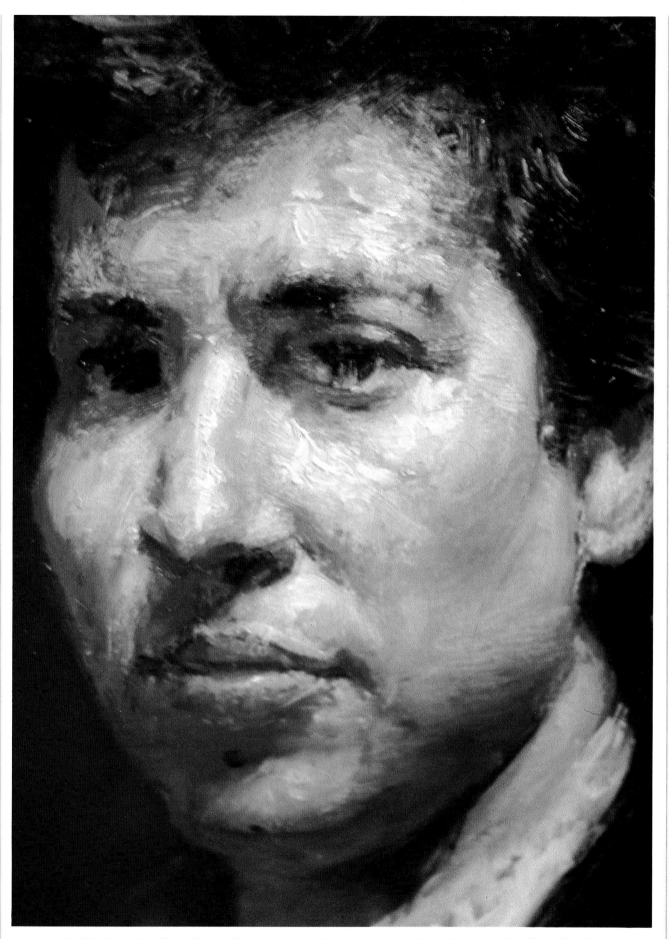

FRANK JANCA *(detail), 16" × 14" (40.6 × 35.5cm). Courtesy of Grand Central Galleries, New York, New York.*

Facial Color.

☐ When you begin painting the face, start with the shadow color first. In mixing your shadow color, make it warm and transparent-looking. One way to achieve transparency in the shadow color is to mix your cadmium colors—red light, yellow orange—with any dark color on your palette. Try combinations of cadmiums with ivory black as a base color until you become familiar with them. Then try other base colors, such as cobalt blue, ultramarine blue, and umber.

Don't worry if the shadow color is not exactly like what you seem to see.

☐ When doing the face, get everything down—hair, flesh, shadow, background—before putting in the light.

☐ Place the nose first. It's the most central feature and the largest. You can then work up to the eyes and down to the mouth.

☐ Flesh areas tend to be warm; bone areas, cool.

☐ Don't overwork the ears. Paint where there's more human interest—the eyes, nose, mouth.

☐ The important thing is to bring the cheeks and chin forward. To do that, add warm colors. Then the shadows on the receding areas will take care of themselves.

☐ If you're using green to paint a cool skin, steer away from making it too green. Try to achieve a more neutral color.

☐ Build up the light on the forehead. Paint it to the edge of the temple (to where the forehead turns at the temple).

Warm colors advance these areas.

Put in the shadows first.

Place the nose, then the eyes and mouth.

LOIS
oil panel, 12" × 10" (30.5 × 25.4cm). Collection of Lois McCune.

Painting the Figure.

☐ With an ordinary nude pose, you must create interest by how you paint, what you put in the light, how you contrast. Otherwise, the painting will be dull. For example, you can create interest here by putting light on the breasts and on the thighs that are jutting forward. Now de-emphasize the color of the robe which is too bright and less important.

☐ Try to think in terms of just painting edges, not features. Remember, flesh has a soft edge; bone, a hard edge. For example, there is a sharp shadow line along the nose where the bone is, and a softer edge at the lower part of the nose where the cartilage is.

☐ It's important to paint a good visible highlight in the beginning as a guideline. It will tell you instantly more about the middle tones.

☐ For a better composition, avoid painting too many different angles in a portrait or figure painting. The hand and the leg, for example, might go in the same direction rather than at askew angles.

☐ Make your figure solid-looking. Build it up. Make a definite statement. Put more dark in the torso, more light on the lap which juts out. Decide where the light starts and where it turns into shadow.

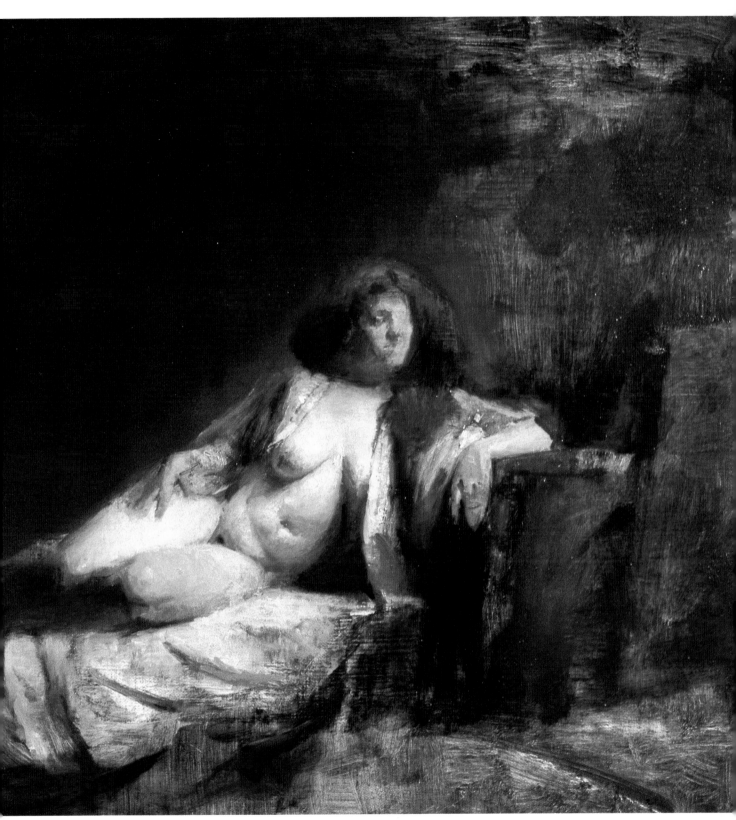

RECLINING NUDE *(unfinished) oil, 20″ × 25″ (50.8 × 63.5cm).*

The Standing Nude.

☐ Choose significant things to paint. The fold in a jacket or shirt should have some meaning; it should relate to the form underneath. Be selective.

☐ Work symmetrically, first one side, then immediately after, the other side. Paint across, from side to side. Painting this way also keeps your colors consistent and symmetrical.

☐ The head should be smaller than life-size. Be sure there's space around it. Everything in life has space around it. Paint it that way.

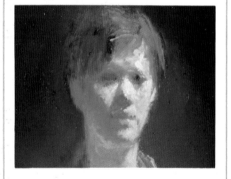

☐ The body follows a natural design.

☐ Be sensitive to your model, whether it's a person or a still life. Give yourself time before you start painting to be sensitive to the pose, lights, shadows, and the various concepts you might choose. Painting is a relationship between you and the model.

☐ When your model's stomach muscles recede make them cooler by adding some background color. The chest muscles come forward so make them more colorful.

☐ Don't put anything (a brushstroke, a piece of color—*anything*) in a painting thoughtlessly. Find a pictorial reason to add everything.

☐ Wherever a form ends, another begins. This is described with a hard edge or crisp brushstroke. Where a form continues, you have a soft edge or soft brushstroke.

☐ A good artist portrays life in universal terms. Ideally, you're looking for the basic, universal, human structure. Personal qualities should be subordinated to the universal. Painting universal qualities makes a good painting, whereas personal qualities in a painting make it weak.

THE GREEN KIMONO
*oil, 20″ × 17″ (51 × 43cm).
Courtesy of Grand Central
Galleries, New York, New York.*

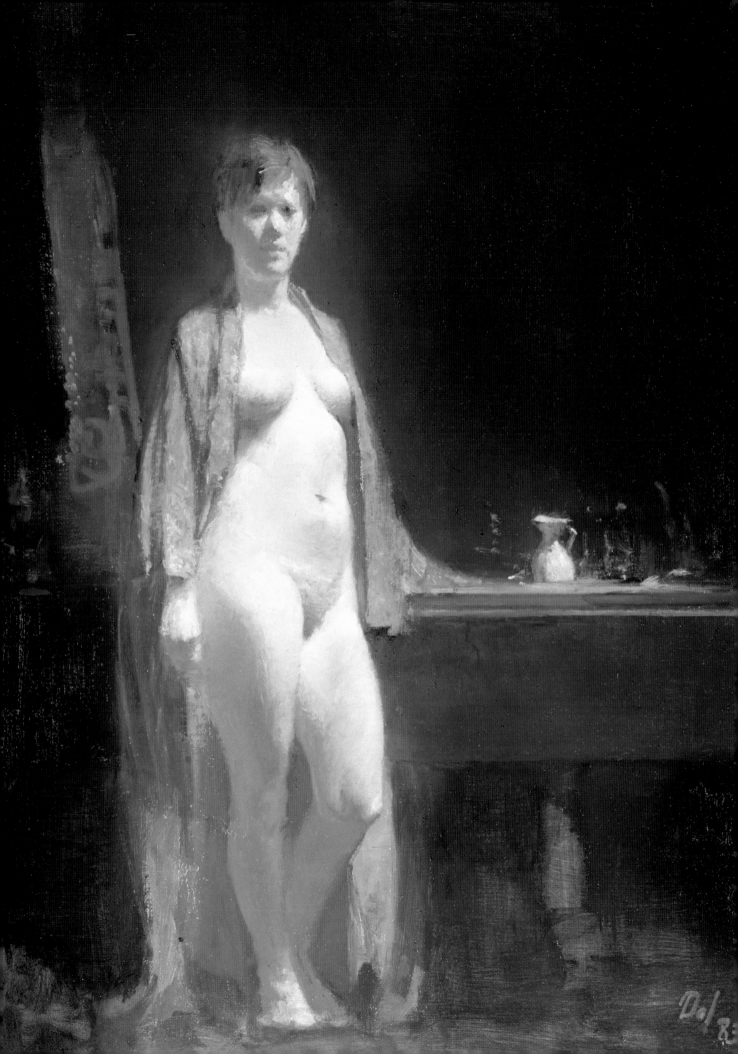

Problem-solving. I once did a 3/4-angled portrait of myself painting at an easel, but I felt the bottom half of the painting was dull and uninteresting. All the action was in the upper half—in the face and the raised painting hand. I finally thought of the solution: I lowered the hand holding the brush and thereby created interest in the bottom half of the painting. As a result, the picture achieved balance and a sense of design.

☐ All light and shadows begin and end in the same direction, from light to shadow, from hard edge to soft edge to hard edge again. On a sleeve, for example, indicate the folds by using the direction of the light and shadow. Don't just apply the paint to the sleeve in a clump.

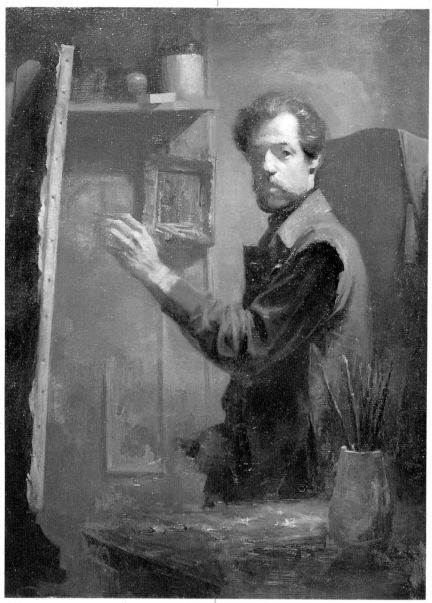

SELF PORTRAIT AT THE EASEL
oil, 28" × 25" (71 × 63.5cm).
Collection of Pam Driscoll.

SELF PORTRAIT AT WORK
oil, 40" × 50" (101.6 × 127cm).
Courtesy of J. B. Speed Art Museum,
Louisville, Kentucky.

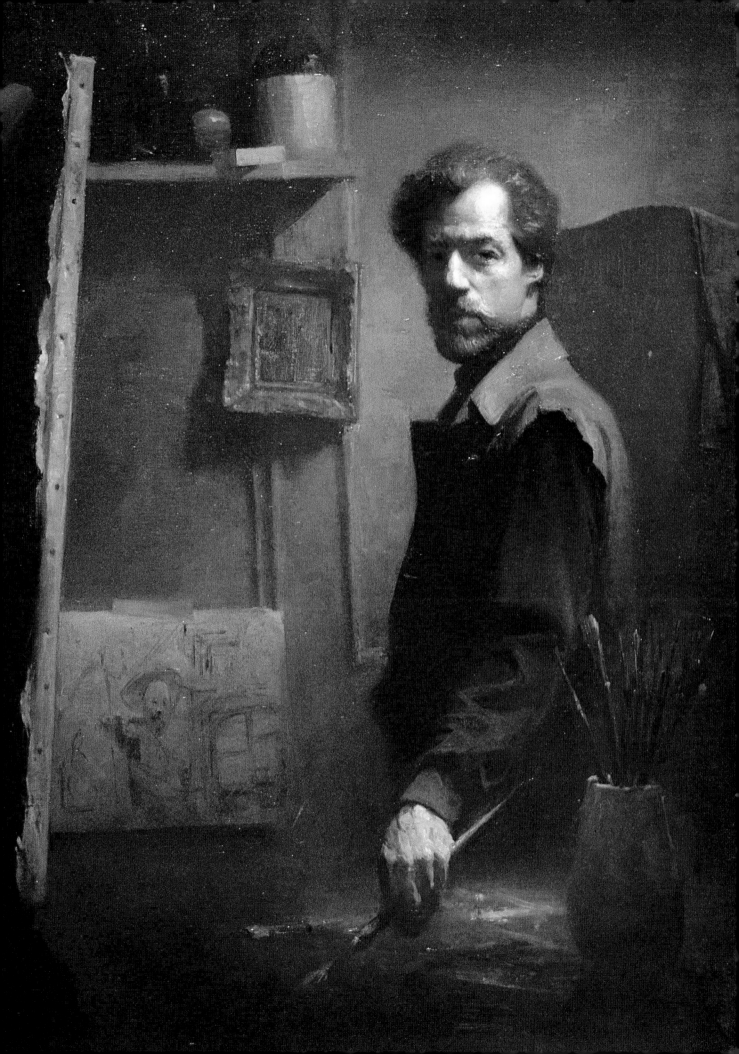

PAINTING BACKGROUNDS

☐ The term "background" here has to do with aesthetics not picture planes. Thus, everything that you don't want to emphasize, everything that is not in the light, is part of the background. When the light is on the face, the hair, for example, is part of the background.

☐ When your background seems too colorful and your fruit still life seems lost, try neutralizing the background. You'll see that the fruit will come forward.

☐ Here are two ideas for painting backgrounds:

1) *Warm background.* After you've decided on the shadow color and value of the element or elements in the foreground, weaken the color and/or lighten the value and paint this as your background.

2) *Cool background.* Decide on the essential shadow color and the local color, then decide on a cool grayed color that will describe the turning planes of the object. Paint this color as your background and the viewer will immediately identify it as air or space.

☐ To cool your background, use raw umber or burnt umber with a little cobalt blue.

☐ In order for one section of an object to recede, something else on it has to come forward. Everything works in relationship.

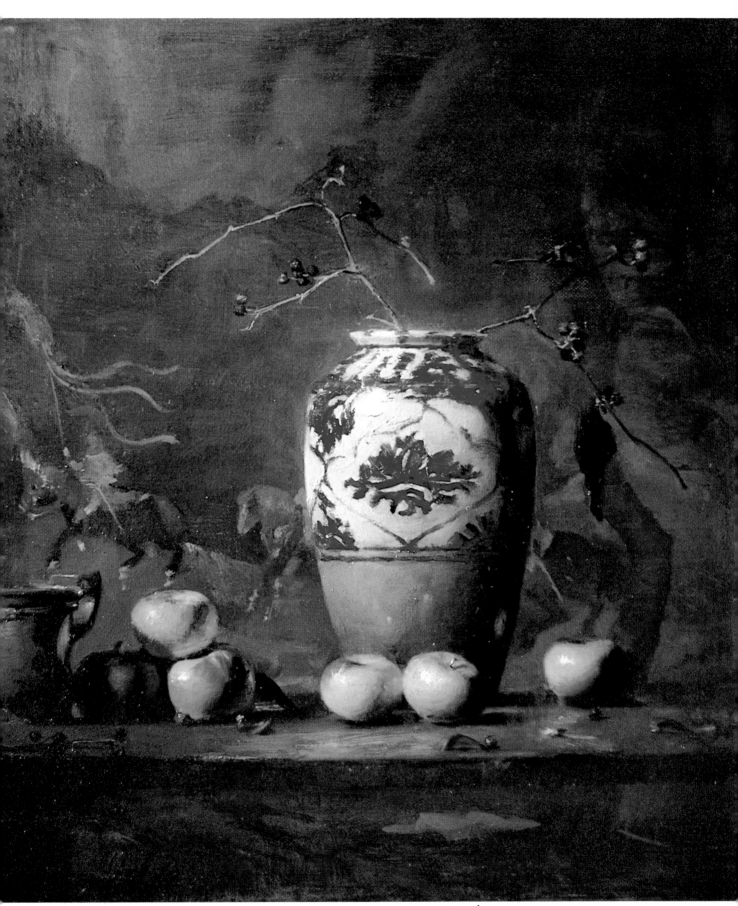

COMPOSITION IN UMBER, RED, AND GREEN *oil, 18" × 22" (45.7 × 55.9cm). Private Collection.*

Creating Atmosphere. Air surrounds everything you paint, both indoors and out. Its tone modifies the color of the background, and in portraits it often *is* the background color. It also softens the color of objects in the light and even affects the color of the shadows. For example, the cool neutral color of the air is in all the cool colors in the lower face in the light; yet it's also present in the warm colors in the light because these colors are not at full intensity but have been mixed with white or some other color, which creates a grayer effect. Even indoors, where distances are not great, air lightens the darks that are farther away because there's more air between them and you, the viewer.

Besides using air to provide an atmospheric quality and to add its own color to a painting, air can be used to make objects recede, because the more air color you put on an object, the farther back it appears to be. So if you're painting a portrait and you want the neck to recede slightly, to its proper place set back from the jaw, rather than have it seem to be on a plane level with the chin,

you can place an overtone of air color over the shadow area. You might also want to put a little air color over the section of the neck that's in the light to help push this area back a bit.

☐ Other ways to treat the background are by painting it as a flat color, or painting the studio setting behind the model. If you decide to use a flat color, one solid tone, use up-and-down strokes alternating with horizontal, until the paint is even and no brushstrokes are visible. If you prefer a studio setting for the background, that is, something more complex such as wall hangings, framed pictures, mirrors, rugs and the like, be sure that the foreground is still the stronger and more vivid of the two. Remember: It's foreground vs. background; one makes the other what it is.

☐ In the shadow areas and the background, try to keep the values close together.

☐ Air color will soften the impact of other colors. It depends on what you want to express: color, or the quality of air.

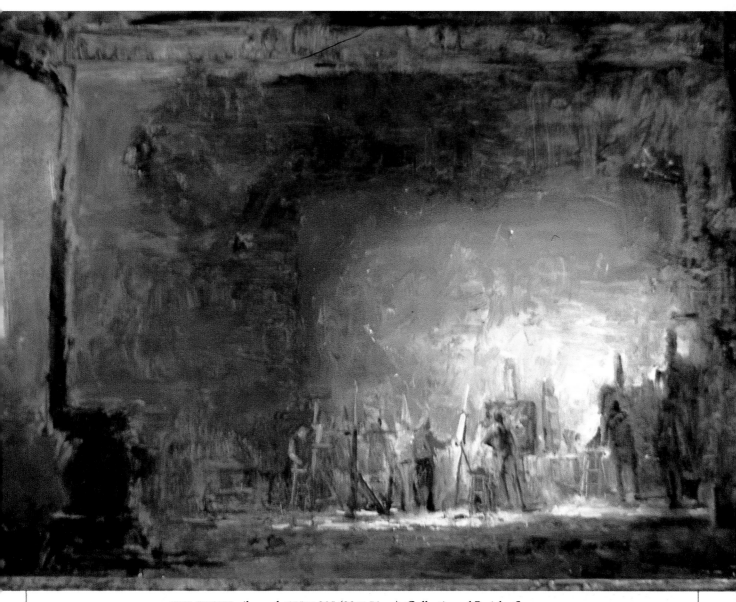

THE GROUP *oil panel, 15" × 20" (38 × 51cm). Collection of Pericles Seggos.*

Keeping Backgrounds Subtle.
When your background is so colorful that your still life seems lost, try neutralizing the background. You'll see that the objects will come forward.

☐ A background is good if you don't focus on it. It should be less significant than anything in the foreground. A guide can be found in the complementary system: Use a cool color, a blue-gray or green-gray perhaps, that is a complementary to one of the warm colors in the face or body.

Remember, the background has to be colorless. You can't have bright colors in both the foreground and the background. Keep the elements of your background similar in value so they won't jump forward. The foreground elements have to be strong enough to make the background stay back. Paint your

background and foreground at the same time. The background recedes, the foreground comes forward. Apply your paints accordingly. Paint in your shadows first, then the background, then the lights.

☐ Anything that moves through space has the color of space. Take some background color and place it on your object.

☐ Backgrounds can have subtle changes in value. You can make the background lighter against the far side of a face or behind a head, because it recedes. Against the near side of the face the background color is darker and stronger. Closer should be darker.

☐ When you have a pattern in the background, you don't need to copy it exactly as it is. Always paint just an idea of it, but be sure it's organized.

☐ Light on objects makes them come forward, but lightening a background makes it go back.

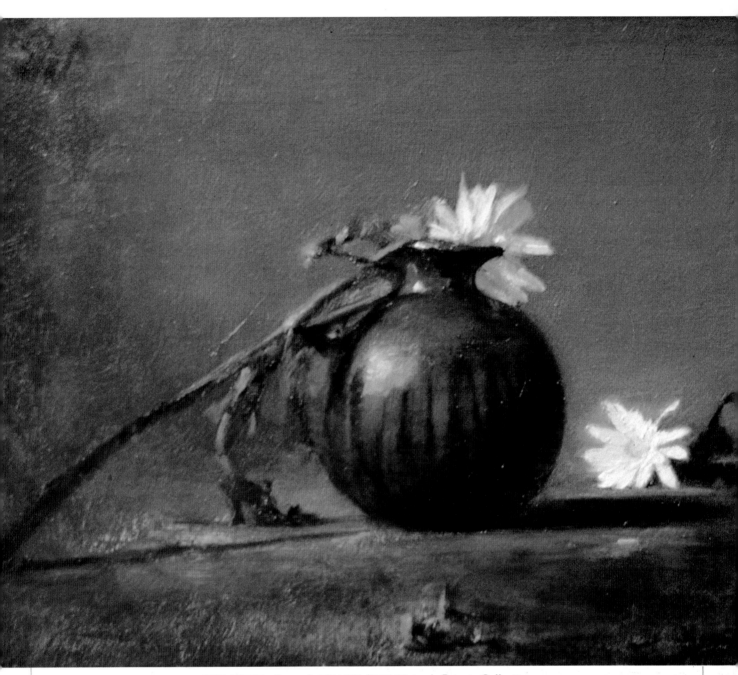

VITA BREVE *oil panel, 8″ × 10″ (20 × 25.4cm). Private Collection.*

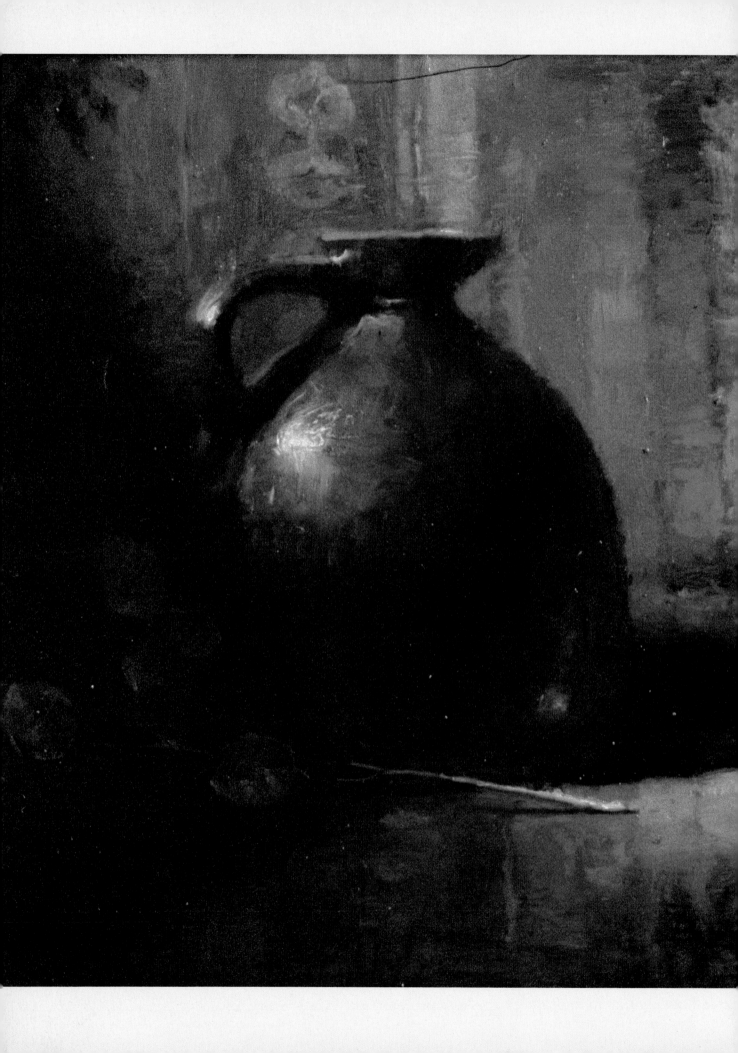

PART FOUR
GENERAL OBSERVATIONS

JAPANESE VASE
oil, 10" × 12" (25.4 × 30.5cm).
Private Collection.

ON PAINTING

☐ Painting a picture should be effortless and simple. If you work at a picture a long time, the picture may appear labored, lacking freshness and spontaneity.

☐ The first piece of paint you put down is always correct. It doesn't become anything until you apply the piece of paint next to it. Relate the succeeding piece to the first. Each piece of paint should be a leading tone to the next.

☐ Do everything the simplest way you can.

☐ If someone else can paint, then you can too. It just takes practice. So if you write with a pencil, you can paint with a brush. It's practice, and thinking about it, and doing it without thinking about it as you work.

☐ Work the whole picture at once.

☐ The rate at which you paint your picture corresponds to the time a viewer will spend looking at it. If you paint quickly, in a slapdash manner, the sensitive viewer will see a superficial picture and give it a superficial glance.

☐ Beginners and mature artists alike should use more paint and more color.

☐ A painting is an illusion of things. You don't paint skin, or an apple, you paint the "look" of it. Turn to page 46 to see how easily you can change an illusion of a grape into a cherry.

☐ Make your objects—a face, an apple, a jar—smaller than life to bring charm and beauty to your painting. If painted life-size or larger, objects and faces tend to look gross. Rembrandt's heads are smaller than life, yet they are very powerful.

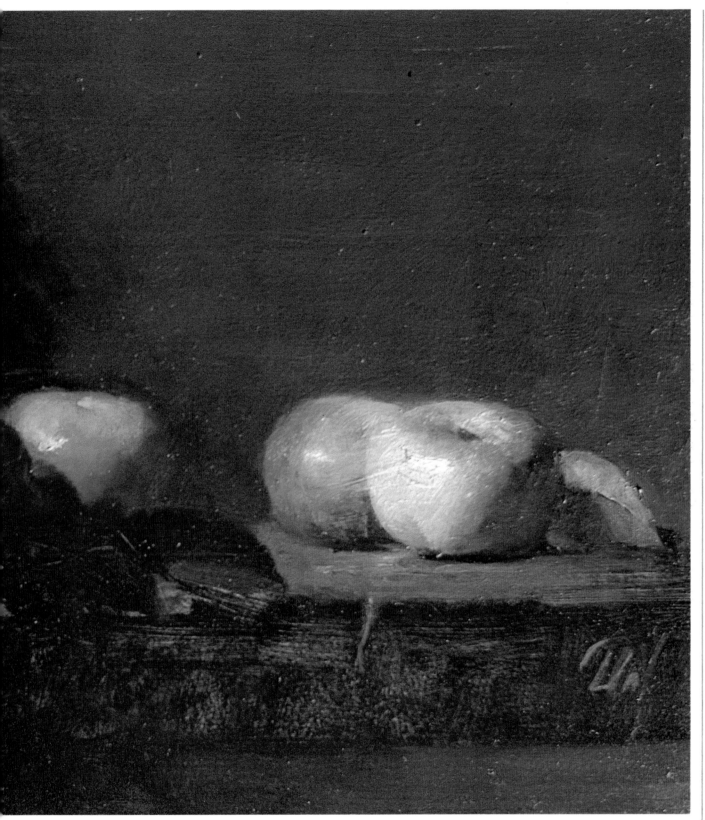

LADY APPLES *oil panel, 8″ × 10″ (20.3 × 25.4cm). Private Collection.*

Contrast light against dark.

Mass similar values.

See the wall as one unit.

Paint the floor as another unit.

Composing a Painting. When planning a large painting with many elements, you will find that a good way to compose it is in terms of abstract shapes, i.e., not in terms of concrete shapes but in terms of light against dark. In other words, approach each section of the picture as a value unit. If you're painting an artist at work in his studio, compose the artist, easel, paints, and table as one general value unit; the model, stand, and chair as another; the wall as one unit; the floor as another unit; and so on throughout the painting. This way everything stays where it belongs.

☐ When I do a demonstration before a class—whether I'm painting a still life or a live model—time is limited. So I focus in on the more important characteristics of my subject and paint them in as quickly as possible. It's the same thing if you have more time, except that you're more relaxed about doing it.

☐ Don't assume that your initial observation is correct. Study your subject. If you're having a problem with a forehead that keeps coming out flat, study the head—for days, if necessary—until you find the solution. It may be—this happened with me—that you're putting the light in the wrong place even though your initial observation indicated the location was correct.

☐ You must decide what you really want to paint about the model or still life, and then how you are going to paint it.

STUDY IN CLOSE VALUES *oil, 25″ × 30″ (63.5 × 76.2cm).*

Starting a Painting. Start each new canvas with the idea of doing a beautiful painting and only secondly of learning to paint.

☐ As you begin work on a canvas, start with a picture or impression in your mind and sketch it in quickly. Then go back and do individual pieces. For example, sketch the whole body first and then go back and put in the anatomy.

☐ Verticals divide; horizontals expand.

☐ Put in the beginning and ending of things, where it starts and where it ends. Every fold, every muscle has a beginning and an ending. Paint should indicate this; paint should lead somewhere.

☐ When you pick up a painting again to continue work on it, don't jump right in doing the important details. Give yourself time to warm up by filling up some background or touching up the shadows.

☐ Beware of focusing all parts of a painting with the same degree of clarity and delineation. Instead, emphasize one element—create a focal point—and de-emphasize the other elements. In other words, do not paint curtains, chairs, and people in the same painting all with the same precision and clarity.

☐ Everything has a shape. Each shape must retain its integrity throughout the painting.

☐ Keep your hand sensitive at all times.

☐ Size and placement of subject matter are the first statement to make on a canvas.

Taking Risks. In order to learn, you have to attempt something different from what you're doing now.
Learn what paint will do. Learn what your brush will do. See what happens.
Apply paint abstractly and discover what using the paint abstractly will create. Watch the paint configurations. Watch everything that happens in front of the brush and what happens if you put this color next to that color, this value next to that value. This is learning "technique."

☐ The risks you are willing to take that might ruin, destroy, or mess your painting will be the measure of whether or not any learning will take place.

☐ Worrying about what your finished painting will look like will inhibit you.

PORTRAIT OF FREDERICK INGRAHAM
oil, 25" × 20" (63.5 × 50.8cm).
Collection of Dr. and Mrs. J. Goldhuber.

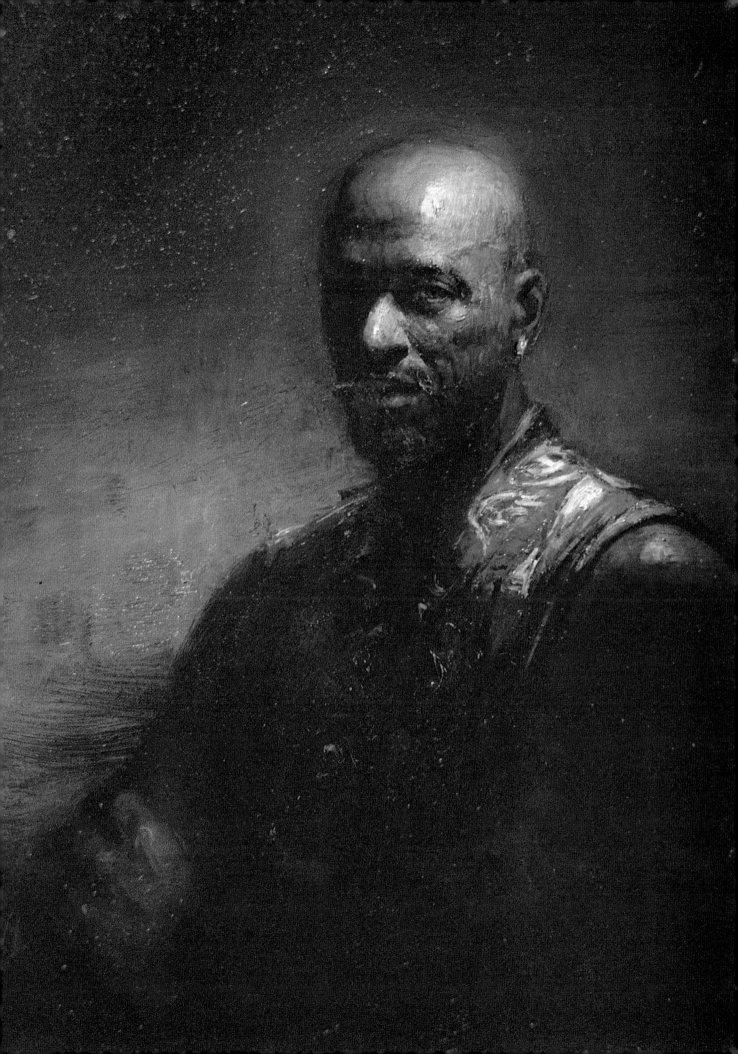

Developing Your Creativity.
Sensitivity must be cultivated immediately. But you cannot be taught how to become sensitive. Just asking "how" puts an end to sensitivity. Becoming sensitive is like learning to listen instead of just hearing.

Listening is the *beginning* of becoming sensitive. Seeing without a screen of assumptions is also being sensitive.

Sensitivity is the opposite of security. Security implies a certain self-satisfaction and a deafness to others.

☐ All "realistic" painting is actually abstract. The painter uses paint configurations, squiggles, pigments, and these purport to be flesh, apples, grass, air, space and so forth. The so-called abstract painter actually is very concrete. Drippings are actual drippings! Paint shot on the canvas or splashed is just *that*. Rents, holes, sawn pieces are, likewise, exactly that.

☐ When you're painting objects, it's work. When you're painting objects as abstractions, it's creativity!

☐ Painting is momentum. If you start in a half-hearted way with a slapdash brushstroke, it will be difficult to be enthusiastic later. If you don't begin well, you won't be able to decide *when* you're going to do it well. A marvelous painting does not evolve from 1,673 careless brushstrokes.

All art students should approach the canvas with serious intent. Always paint as intensely as you can. Don't wait until you're an experienced painter.

☐ Near always means more—more color, stronger value, sharper edges, more contrast.

THE GATHERING DUST
oil panel, 12" × 14½" (30.4 × 36.8cm).
Collection of Jonathan A. Leffel.

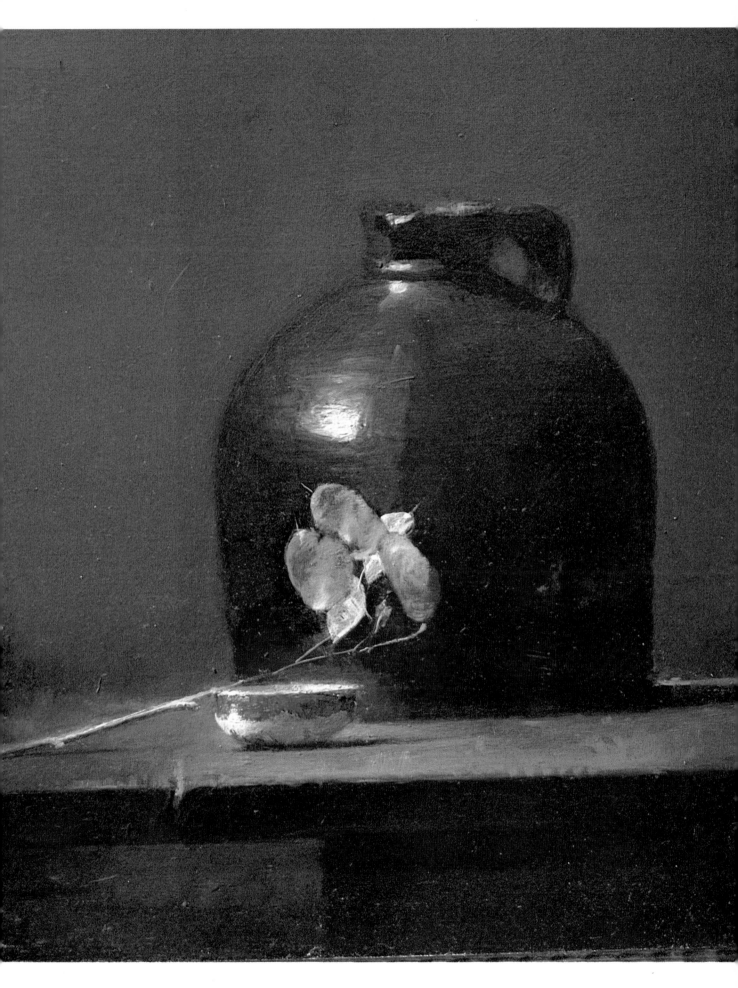

Primary interest.

Secondary interest.

Tertiary interest.

Thinking Like an Artist. Learn to focus on only one thing. Have *one* place of intense focus: one main area, then a secondary area, perhaps a tertiary one, but always one primary area.

When you look at me, you look at my eyes. Everything else is subordinate. That is the way you have to paint. You must get the picture to come out right in the sense that it has a strong focus. You're saying to the viewer, "Look at this. Don't look here."

Learn to think visually, as an artist does. In other words, think abstractly as you paint, not "I'm going to paint the robe now," but "I'm going to put a light against a dark." If you look at objects this way, you'll begin to think this way. Think in terms of relativeness, this light against that light. Simplify your thinking to a very rudimentary level: Think this spot of color against that spot of color, this light against that light, *not* that you have to paint a robe.

☐ Being a good painter is a question of risk and letting go; it's not being afraid to make a mistake.

☐ When you get involved in doing something, it doesn't seem like hard work. It's the prospect of doing something that is difficult to cope with. So doing is easier than thinking about doing!

☐ When you're a student, you should try a lot of different things: color combinations, brushstrokes, mediums, surfaces. It's a good time to experiment and find out what you're comfortable with. It should be a period of trial and error.

☐ Today you have the competition of photography and the weight of past master artists. So it's much harder now to be a good painter.

WINE VELVET
*oil, 30" × 42" (76.2 × 106.6cm).
Courtesy of O'Brien's Art Emporium,
Scottsdale, Arizona.*

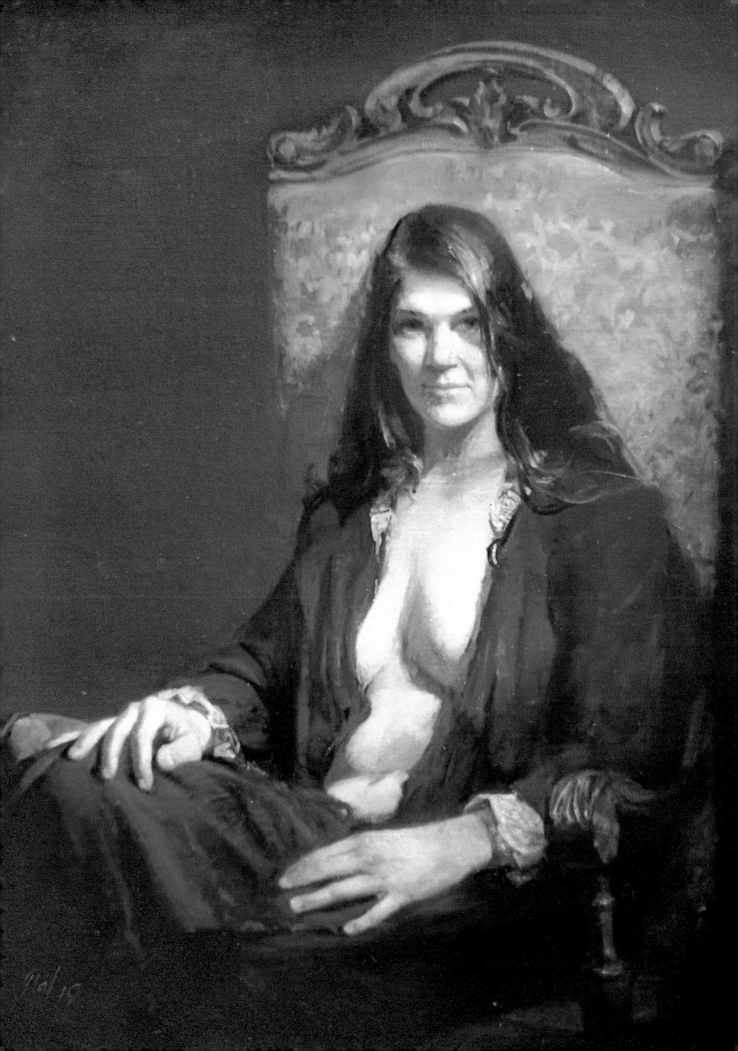

Value

Color

Edges

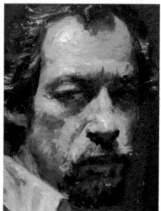

Paint quality

Solving problems. Understanding painting takes an instant, but it takes time to reach that instant. You must do the work; you must put in the time. You must be "immersed" in painting, as in life.

☐ Painting pictures means solving technical and esthetic problems. It is not a mystery. There is no aspect of painting that cannot be discussed in simple, pragmatic terms that anyone can grasp. Great paintings and not-so-great paintings are so characterized for reasons that are evident rather than mystical.

☐ The artist has very limited technical means at hand. Value, which may be lighter or darker, is one means. Color, which may be more or less, is another means. Edges, harder or softer, are another means. And paint quality, thicker or thinner, is another means. That is essentially it—there's not too much to learn.

☐ Be aware of the artistic possibilities of a picture. Seeing and understanding the artistic possibilities improves technique.

☐ Learning all the techniques will not help you paint what you can't "see". You have to understand the "painting" of a picture. Technique could take over and make your work stiff. Let go of technique.

☐ Acquiring information is not learning. When a student has an insight it rarely, if ever, has to do with acquiring more technique. It has to do with "seeing" clearly. Accumulating more technical expertise never results in the kind of fulfillment that understanding does.

AT THE EASEL
oil, 28" × 25" (71 × 63.5cm).
J.B. Speed Art Museum,
Louisville, Kentucky.

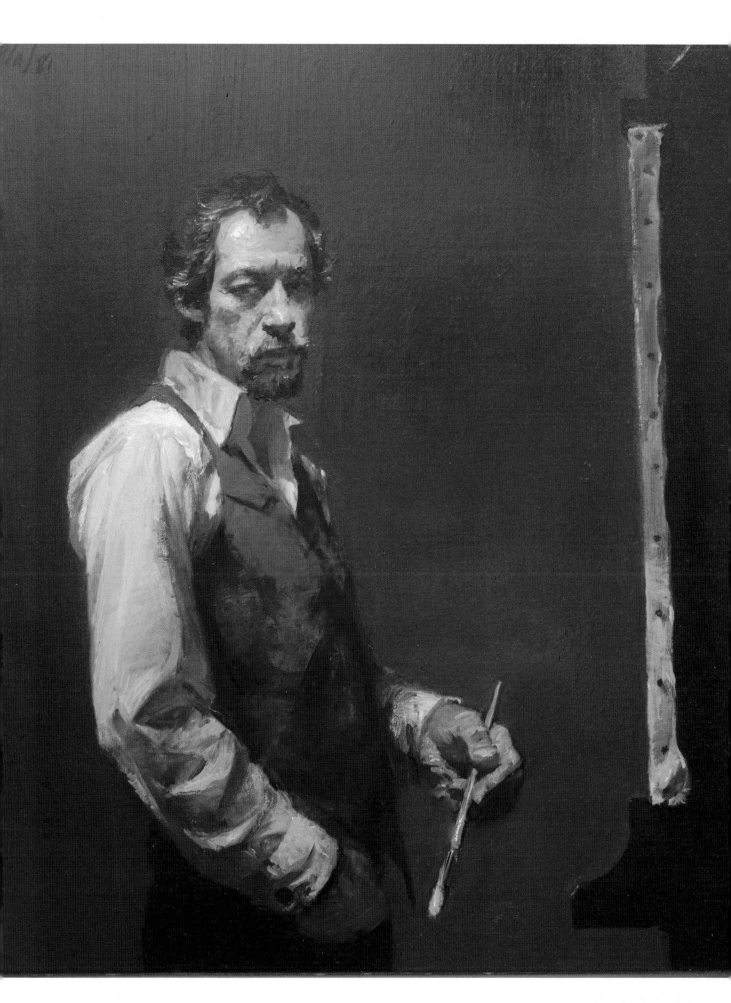

When a painter paints, he is solving problems. We know reality consists of at least three dimensions but the painter's surface is flat. The painter is constantly dealing with the problems of translating a three-dimensional reality to a two-dimensional surface; this creates problems of color, value, composition, and design, relationships and esthetics. The overall problem is the translation needed to give the illusion of multi-dimensional qualities on a flat surface.

Each problem is divided into relationships of more or less: color and colorlessness; light and dark; recession and protrusion; harder and softer edges, thicker and thinner paint, etc.

☐ Know where it is important to focus the attention. Then use a tool—value or color or impasto, for example—to focus the viewer's eye *on that area*.

☐ A painting looks overworked when it contains too many separate pieces. It looks too busy.

☐ Today, the biggest difficulty in learning to paint has been created by our education system. Students are conditioned to be passive receptors of information. Learning to paint requires active participation. Many students patiently amass information with the false confidence that receiving this information alone will teach them to paint.

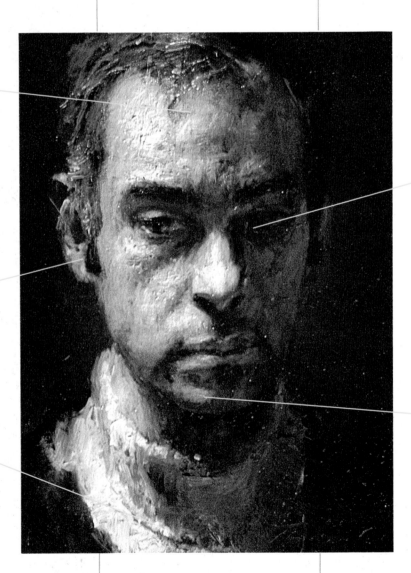

Color and colorlessness.

Recession and protrusion.

Harder and softer edges.

Light and dark.

Thicker and thinner paint.

LUDWIG OLSHANSKY
oil, 22" × 18" (55.9 × 45.7cm).
Collection of Mr. and Mrs. L. Olshansky.

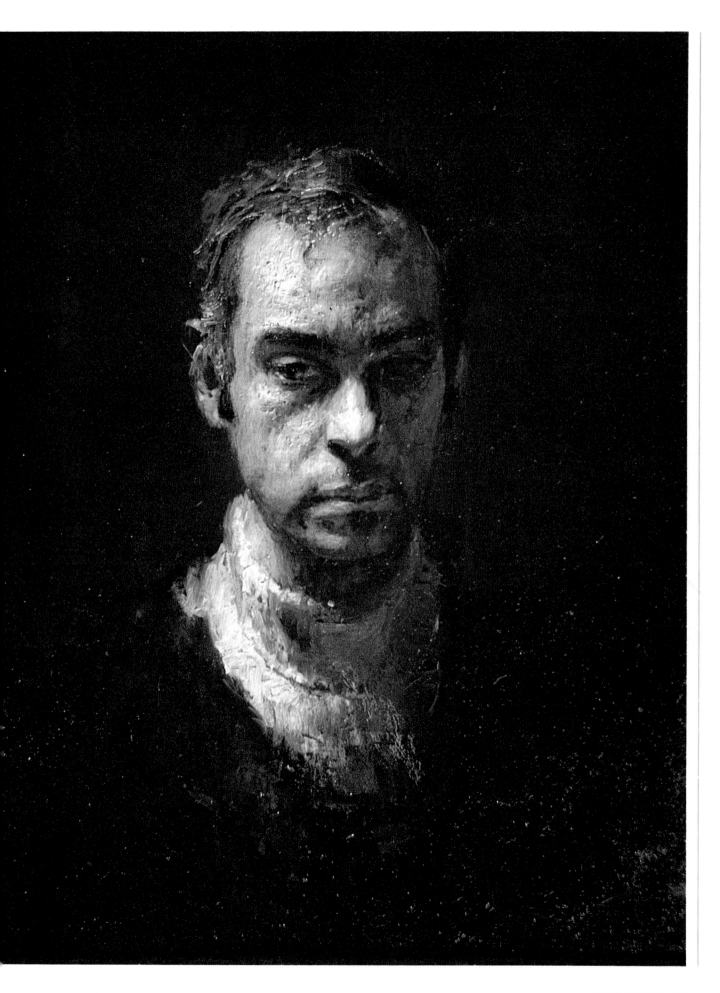

Building Ability Through Practice. Consistency, or, repeating the same colors and values in the same way throughout a painting, makes the painting "readable," that is, knowable, graspable, appreciable.

☐ A good painting consists of a lot of "middle" and a little bit of "end." The ends are highlights and accents. The middle is the general tones.

☐ Students tend to regard painting as a step-by-step process, building gradually to the end. They overwork the middle trying to finish their painting. The middle, which is the general tones, obviously cannot be finished. The way to finish a painting is to put in the end, the highlights, accents, and work *back* to the middle.

☐ If you feel there is something wrong with your painting, do not "fix" the parts. Fixing parts will never improve your work. You must find what is wrong with the entire painting. That is what's troubling you, not the parts.

☐ You can't get a whole picture by constructing it piece-by-piece. You can get a whole only by seeing holistically. What you see is what you paint: If you see just pieces, you'll paint just pieces. If the *whole* is good, the individual parts are relatively insignificant.

☐ A painting is a measurement of each artist's viewpoint.

☐ A student's primary goal each time he begins a canvas should be to paint a beautiful painting and, only secondly, to learn how to paint.

THE SITTING
*oil, 40" × 50" (101.6 × 127cm).
Collection of K. Lotsoff.*

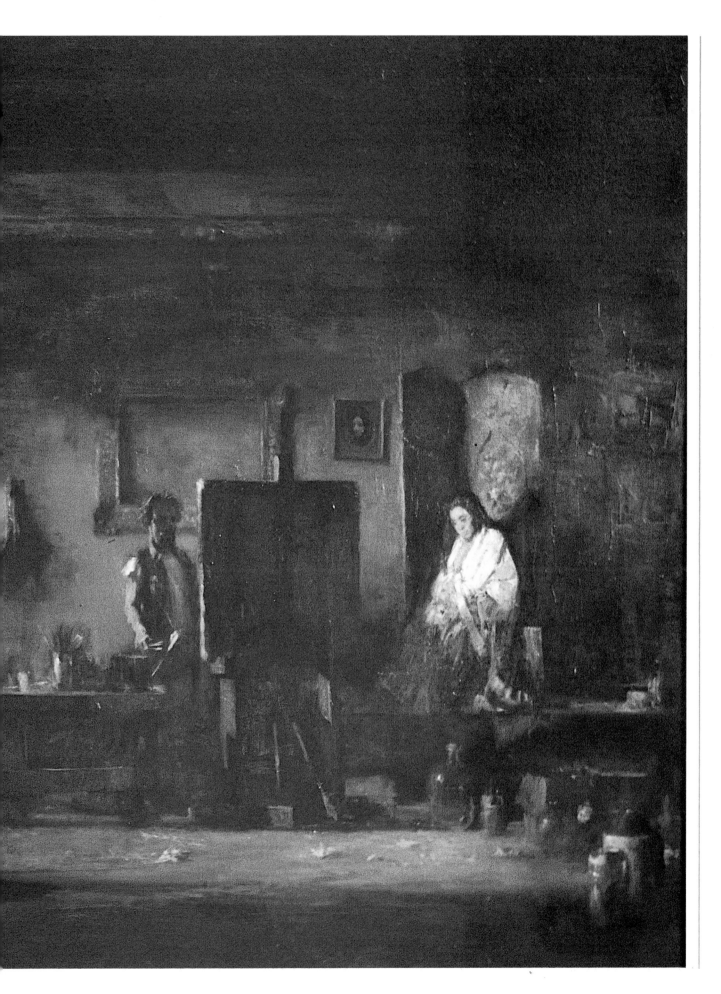

Sculpting the eyes.

Sculpting the nose and lips.

Sculpting drapery.

☐ Painting is more like sculpting than like drawing. Drawing is like filling in the lines of a coloring book. In painting and sculpting, you have space and air and depth.

☐ A painting is a matter of selection from thousands of pieces of information bombarding the pupils of your eyes. *The key is making the selection.* It's like being a writer. The writer has millions of words to choose from and only the words that are most appropriate must be selected.

☐ You can always correct an oil painting. You can't ruin it.

☐ Never assume that what worked once will work again. Figure it out again. Think afresh.

☐ Painting "more" or "less" is always the solution.

☐ When you're learning to paint, you deal with whatever the situation is. It's like rolling with the punches.

☐ From the beginning, you have to give what you're doing your very best and work as if you're doing the most important painting of your life—and yet be willing to destroy it.

☐ Learn what paint will do.

☐ One of the problems in learning to paint is learning what your tools will do to translate what you see. Your equipment is limited to value, color, edges, and impasto. These are all the tools there are to create the illusion of reality on your canvas.

☐ You're dealing with tricks of illusion but *be as accurate as possible*.

EARLY SELF PORTRAIT
WITH BLACK BERET
oil, 28" × 22" (71 × 55.9cm).
Private Collection.

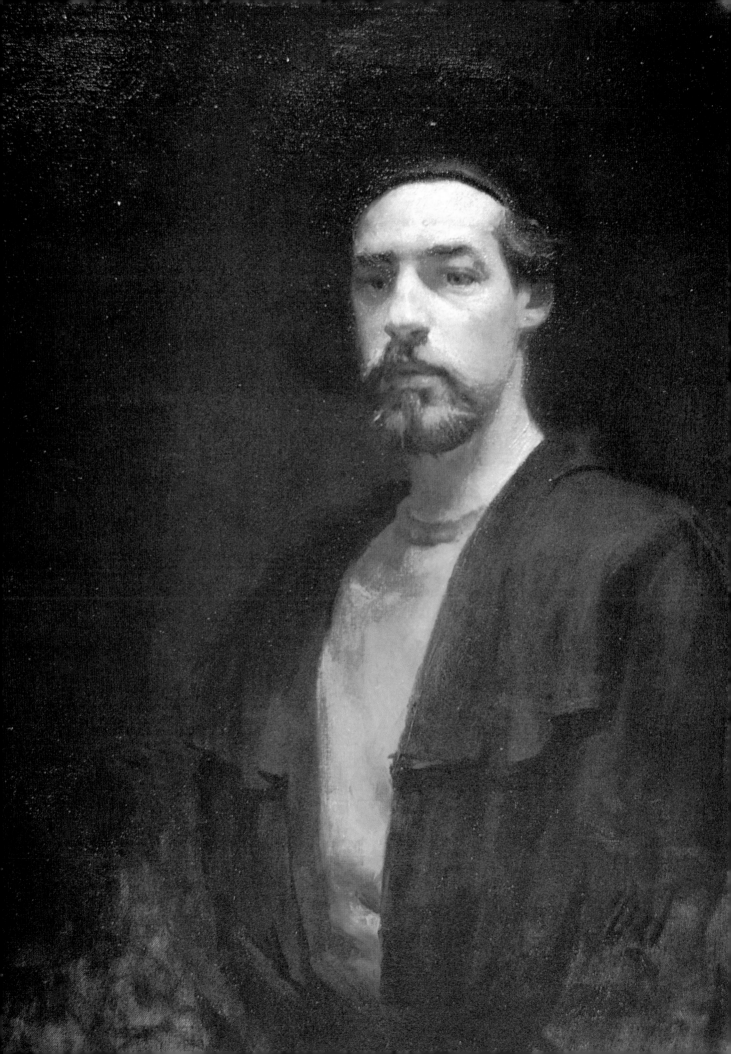

Creativity and Art. Creativity in painting means doing something differently each time you paint. It's learning how *not* to be mechanical in your thinking and seeing. It's avoiding the use of formulas, repeating old solutions, painting the same way, or starting at the same spot each time.

You can paint fifty paintings of an orange and each painting can be creative if each time you do the orange you see it anew, as a particular orange in a specific context at a certain moment in time—then and only then.

☐ Painting was developed by people. It grew simply and slowly from cave art and primitive drawings, from line to perspective, from the flat to the more sculptural. As artists learned to control their materials and as their grasp of the subject in-creased, the range of what they tried to do expanded. The better painters were those who had a greater grasp of the significance of the things around them. They were not simply copyists.

☐ At each stage your picture should look good, and you should try to make it look good at each stage.

☐ Think of the finished picture. Do everything as soon as possible for the finished picture. In fact, do the finished painting *now*. You must think instantly of painting an artistic picture.

☐ Delve into life—a good painter understands the significance and importance of what he sees. This discernment makes the difference between a good and bad painter. This is more important than talent.

GEORGIA
oil, 25" × 20" (63.5 × 50.8cm).
Collection of the Artist.

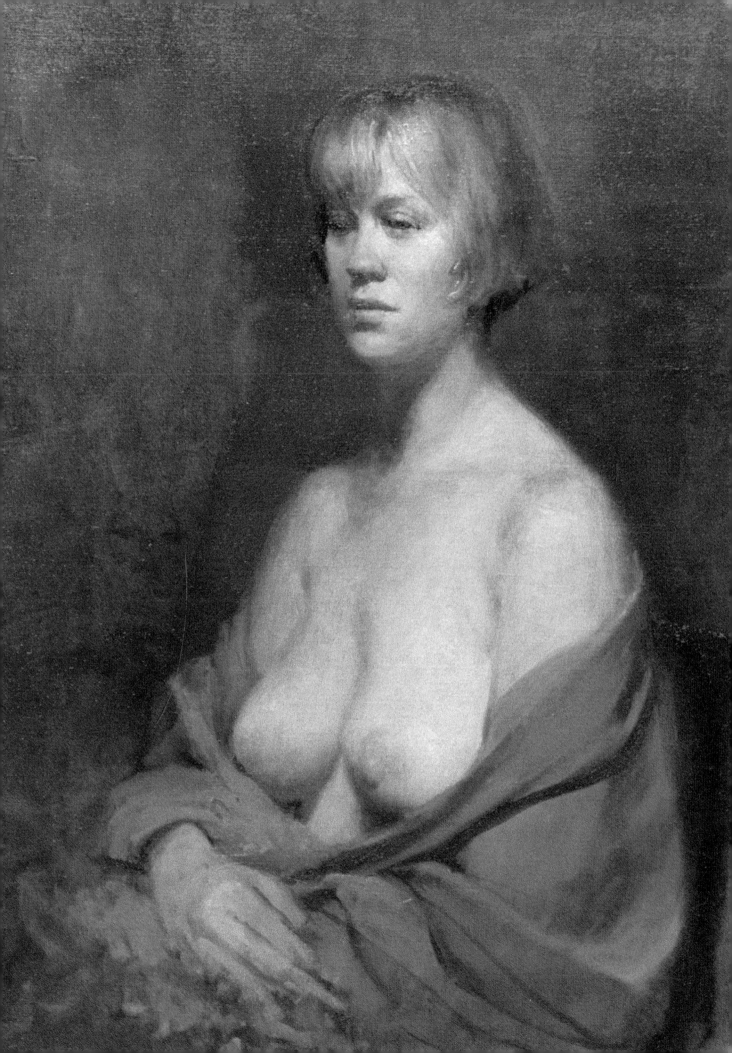

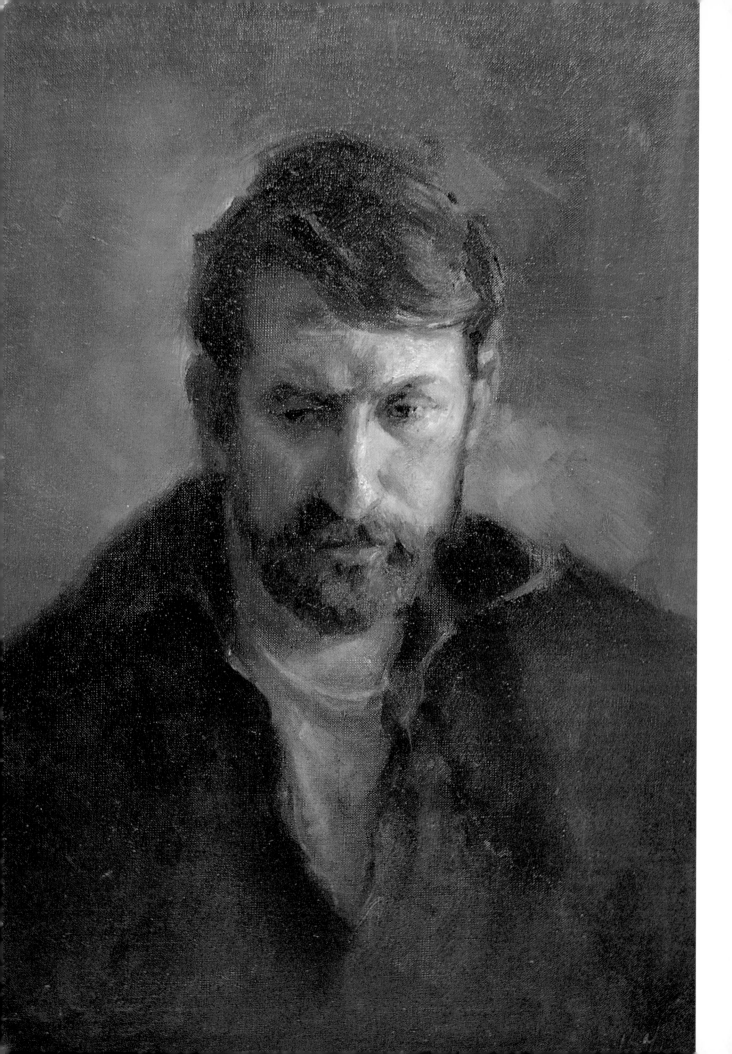

ATTITUDES THAT CAN HOLD YOU BACK

"Teach me the 'secret' of how to paint."

Art students have the attitude that accomplished painters have some sort of "secret." If the student could only be privy to the "secret," then a few sentences would reveal the key to painting.

Let me dispel this belief. There is no one "secret." The teacher imparts his knowledge by words and his skill by demonstrations. The pupil receives, *but nothing happens*. He or she picks up the brush and continues painting as before.

What has to be stressed is the necessary and all-important *time interval*. When a teacher tells you something meaningful, a "painting principle," it will take time and practice before you can understand the principle and cope with all its ramifications. This is the phenomenon of learning to paint, and there is no way to overcome it. To paint well, you must experience painting. To become intimate with a principle you must do many, many paintings.

"Teach me the 'techniques' of painting."

The full-fledged painter knows that it's not a question of learning *how to paint* but *what to paint*. The student, on the other hand, comes to school to learn "how to paint," to learn "the technique of painting." This holds him back. His attention should be on trying to learn *what* to paint. The goal of the artist is to create a painting, to make a picture. To do this, you don't copy indiscriminately. You concentrate on what to paint, and that makes *all* the difference. Technique has a bearing, but it's less important.

"I have to copy that fruit exactly as it is."

Each thing has a special essence, that which makes it that particular thing. An orange is different from a pear because of its shape, color and texture. Good painters are able to focus in on the simplest aspects of each object, and with a very few colors and brushstrokes, put down what makes each thing recognizable. They can separate what is more telling from what is less so. They are able to focus on the universal, not the individual.

"I have to paint every wrinkle."

Certain aspects of a subject are more important than others. Wrinkles or folds that express movement or form are more revealing than accidental ones that result from a momentary pull. These are unimportant. Better painters select those folds that describe movement, dimension and form. Or instead of painting individual hairs, they show hair which expresses the form of the skull underneath. It is the universal, not the individual or personal, that the great artist searches for.

Your own attitude is of prime importance. It's essential to be able to look at something and see it as clearly as possible, without prejudice and without preconceived notions. A purple plum is not purple. It is gray-black with a touch of purple. You must try to understand what you are looking at, what it really looks like, how to get it on the canvas, and what will make a good picture.

"Rembrandt was a genius. I could never paint like him."

I want to say a word about the attitude of intense admiration that many students have for "artists," an emotion that merely serves to separate the two and further delay student progress. Such students tend to revere the great painters in museums as "gods" and "geniuses." They feel small in comparison and think they can never be as good.

Their admiration keeps them from actually seeing the work of these men, these painters who were just people trying to solve problems.

You can be as good as one of these artists. It depends on how much work you're willing to put into your art, how much frustration you're willing to bear.

Talent is the willingness to figure it out. It's not a mystical or metaphysical thing. It's the ability to relinquish all your assumptions and conceits in order to learn.

FRANZ
oil, 22" × 16" (55.9 × 40.6cm).
Collection of Mr. and Mrs. Murray Cohen.

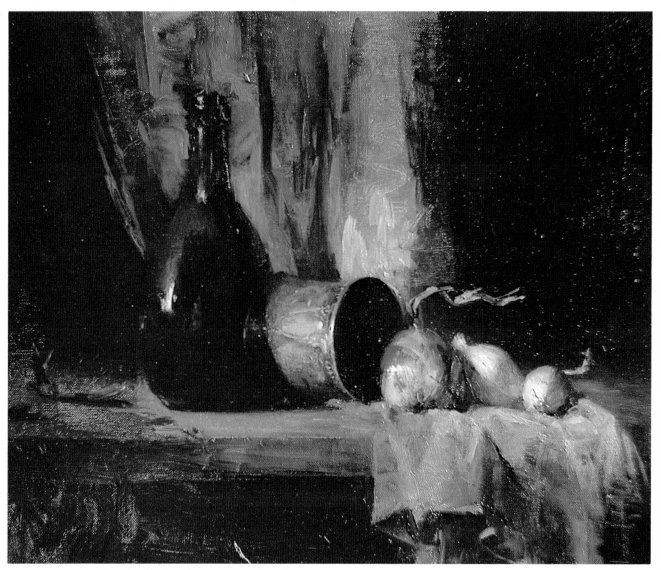

COMPOSITION IN PURPLE AND GREEN *oil, 18″ × 21″ (45.7 × 53.3cm). Private Collection.*

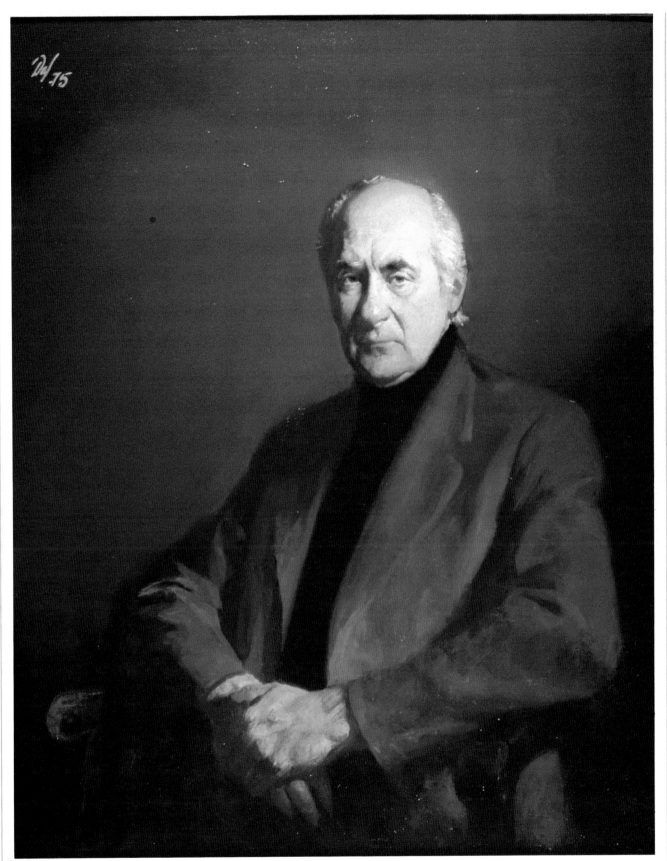

PORTRAIT OF JOE SINGER *oil, 30″ × 25″ (63.5 × 76.2cm). Collection of the Artist.*

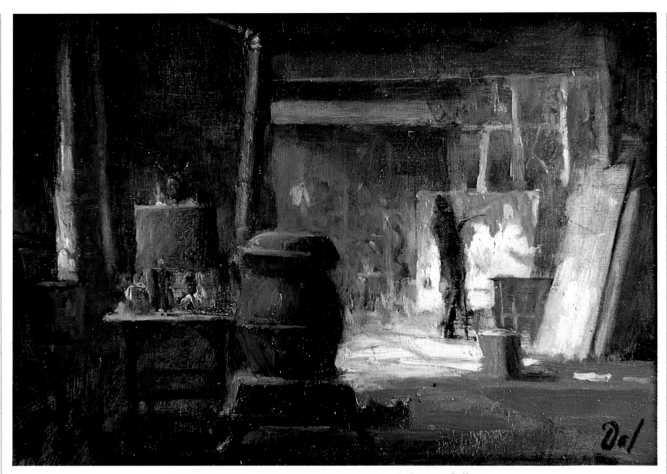

STUDIO MOOD *oil, 10″ × 24″ (25.4 × 60.9cm). Private Collection.*

INDEX

DISCARD

Concept by Bonnie Silverstein and Bob Fillie
Edited by Robin White Goode
Designed by Bob Fillie
Graphic production by Hector Campbell
Set in 11-point Palatino